For Andrew,

You're honestly one of the reasons I ever picked up a camera, feels unreal being able to send this your way. Glad to call you a friend, sending love.

Best
-F

Wilder

LIFE ADRIFT WITH FORREST SMITH

THOUGHT
CATALOG
Books

THOUGHTCATALOG.COM
NEW YORK · LOS ANGELES

JUNE 28TH, 2016 AT 3:21 AM

Last night I was up late talking with a friend. We talked about life and how weird it is growing up, and about where we might be headed and the fears that accompany change. We came to the conclusion (more realization) that our time isn't infinite, and although we're young it's not something that's to be taken for granted. Moments are sparse if you don't seek them out. Life will pass you by. Chase dreams. Find freedom in change and find the courage to change. ALWAYS keep moving. And become who you want to be. I want to challenge you to do this today. This month. This year. Be unafraid. Ambitious. Be unashamedly you. It'll take you places, I promise.

—*Forrest Smith, age 19*

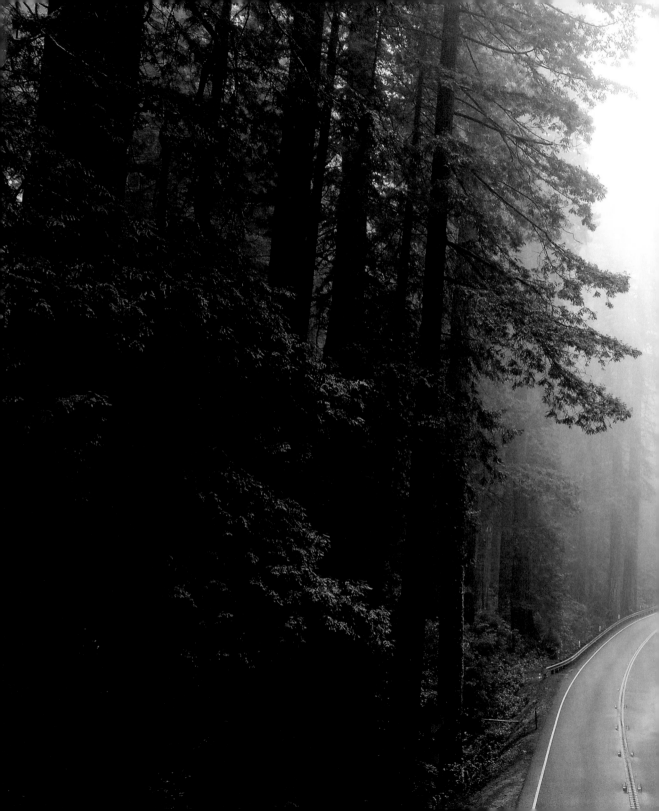

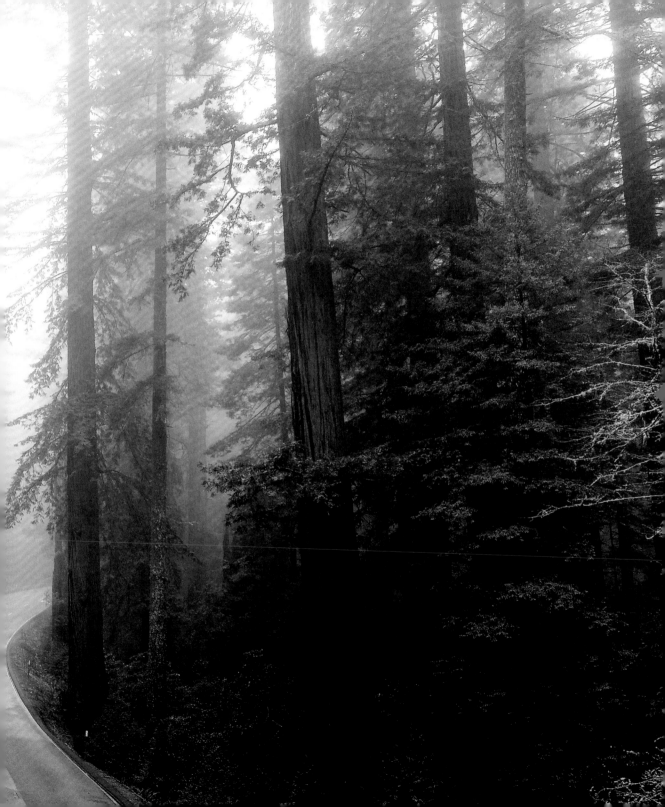

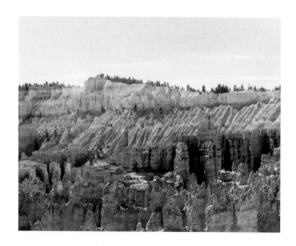

THE BEGINNING

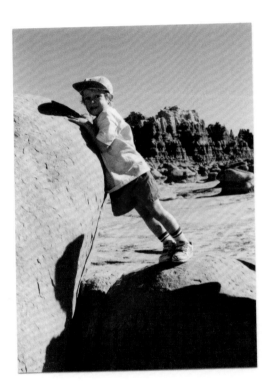

My journey began in Colorado. I was born and raised in a small mountain town tucked away at the end of a valley, one road in, one road out. During the winter, snow piled higher than the stop signs and during the summer flowers would blanket the hillsides as if someone had taken a paintbrush to the Earth itself. I can't count the number of star-filled nights or sun-bleached days I spent roaming the endless mountain terrain that I was lucky enough to call home.

It's easy to form a sense of nostalgia for places like this—places that are so full of wonder and memory and feeling. Until 17 my life was contained to this small corner of the globe. Skyscrapers of mountains and backroads leading to infinity. From a young age, I knew these spaces mattered. I knew the value of the natural world; I knew that it was worth protecting and cherishing. When one builds a connection with the outdoors, I think we begin to connect with ourselves a little deeper. We live in a world of curation and fabrication. It's a time when almost everything has been touched, changed, and been built upon. I don't hate modernity but there's truly something special about digging your toes into warm sand, swimming through fresh water, breathing clean air. These are the things that birthed us and gave us life. They're natural—untainted by the human hand. What these moments provide is irreplaceable no matter what technology is invented next.

Breathe deep. Feel the silence. Take the time to connect with intent. These are all mental notes I make when I depart into the unknown. A life adrift is a beautiful thing, moving one foot forward at a time.

COLORADO, THE EARLY DAYS

As I grew old, the concept of home became complicated for me. I think this is normal for those that adventure out, seeking things beyond their line of sight. From a young age, my sense of "home" became an ever-changing thing. It changed as I traveled beyond my place of origin; it changed as I saw the world around me and all it had to offer. I've felt at home in the arms of a loved one. I've felt at home in the desert as a warm wind from beyond the horizon brushes my face. Ultimately as I grew up, I found that "home" was a feeling more than a place.

At 17, documenting my journey through photography became my way of expressing this. There are special little moments in life for those that watch closely—signs and superstitions that hide in the everyday. I think of images as little notes to myself—memories of seemingly small instances that speak to larger truths. In these captured moments, we find both dreams and realities—ways we wished to see the world and ways in which the world already was.

Within these images, you, too, may find dreams and realities—subtle signs and notes-to-self. At 17, I found a lust for life: dirt roads leading into the mountains beyond my Colorado upbringing, journeys I had yet to embark on, and places I had yet to see. These were youthful days bleached in sun, cleansed in mountain lakes, hidden in valleys and thickets. Star-filled nights and little talks behind the crackle of a fire.

These were days that taught me to feel at home and gave me the world to feel at home in. Running free in the truest sense. I always seem to return to these feelings, no matter where I am or where this path is leading me.

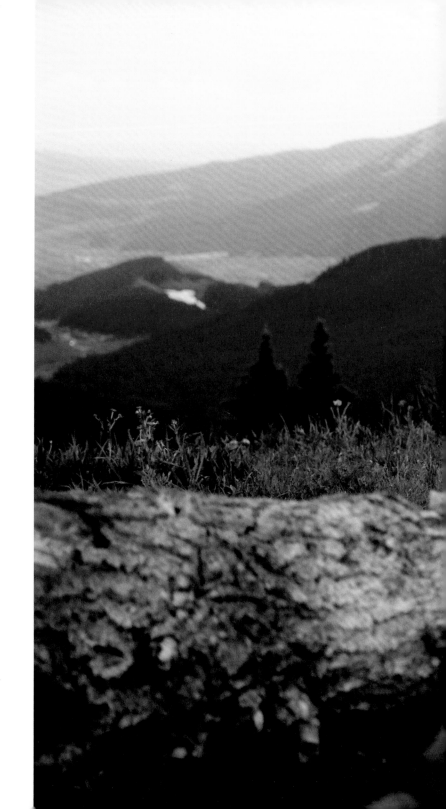

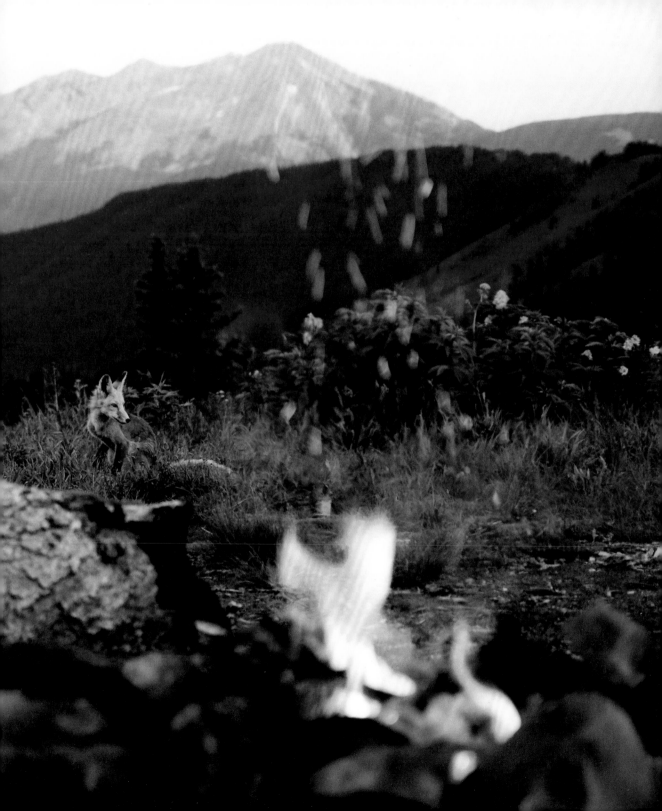

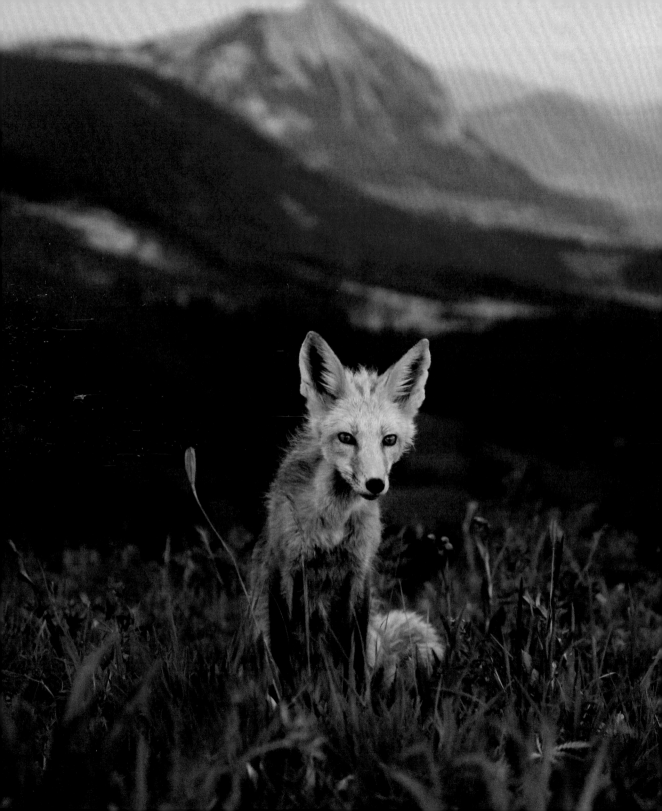

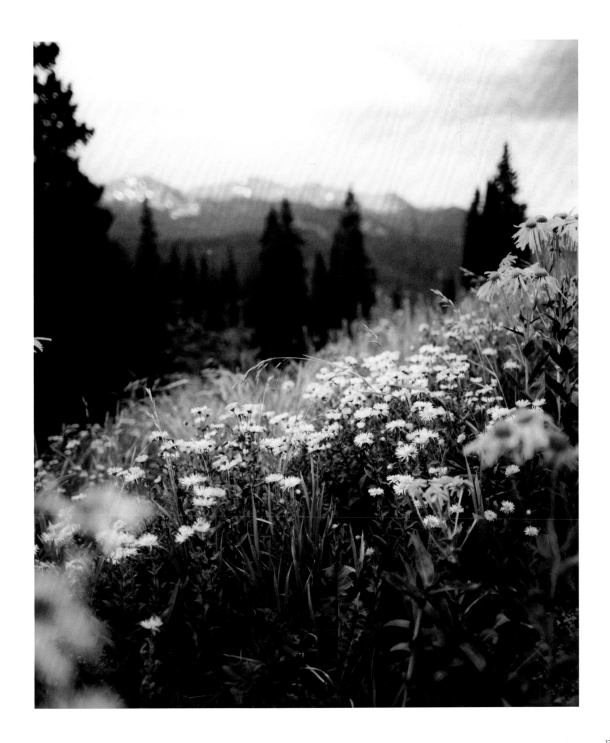

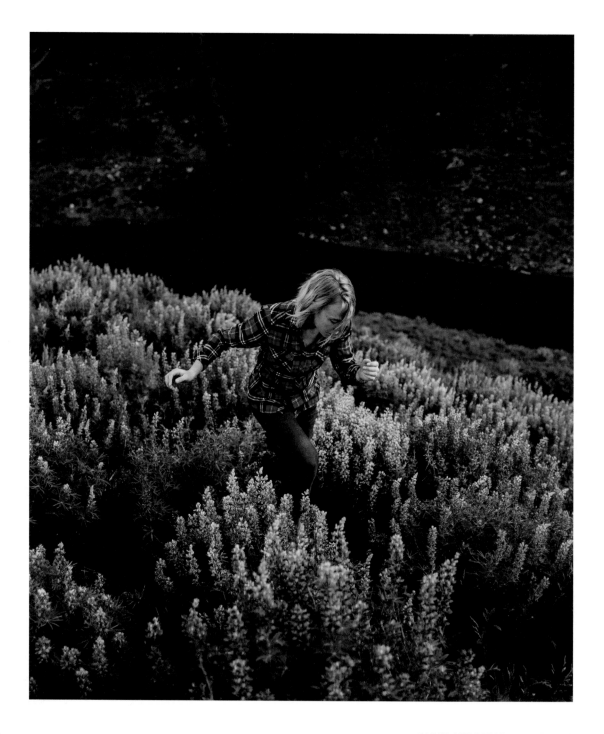

SARAH ANN BRUSH JUNE—2016

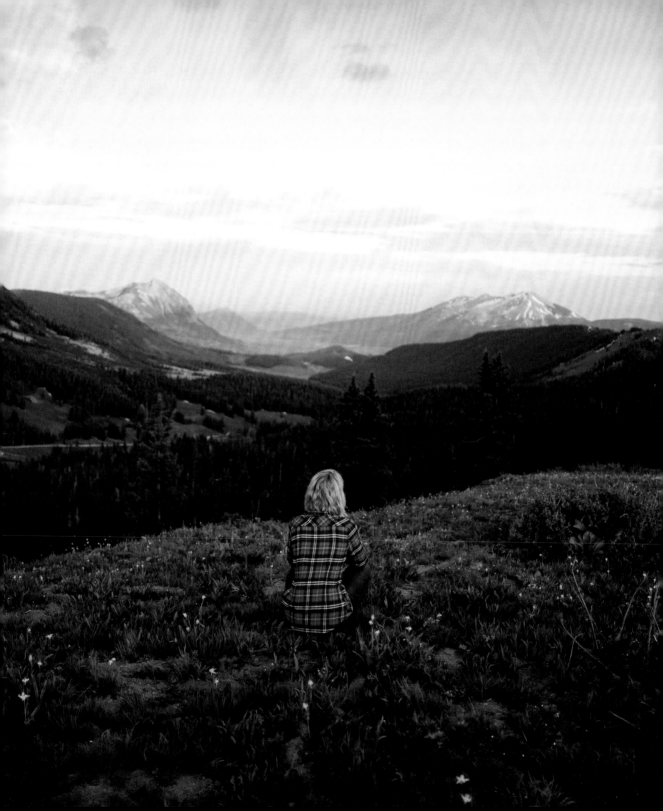

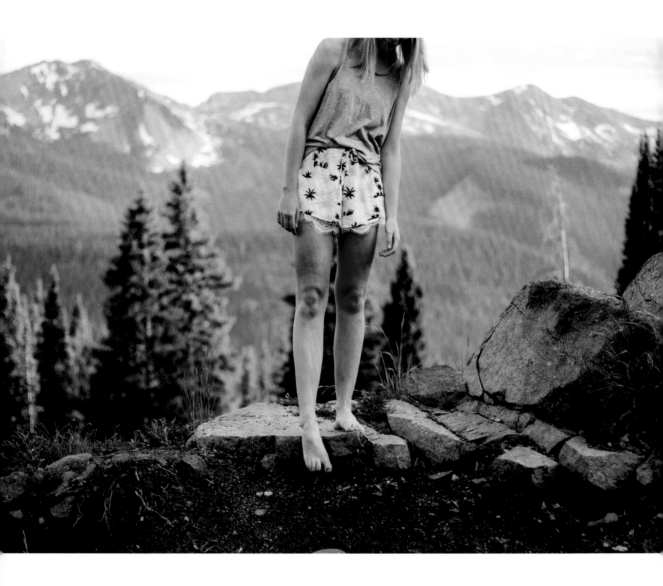

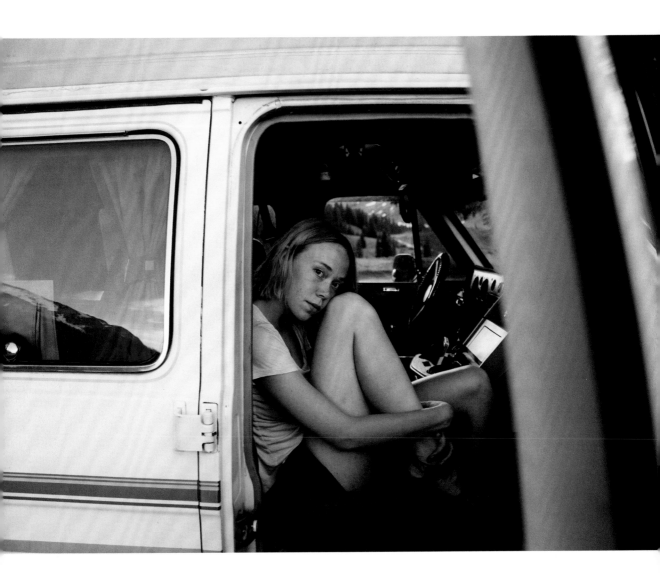

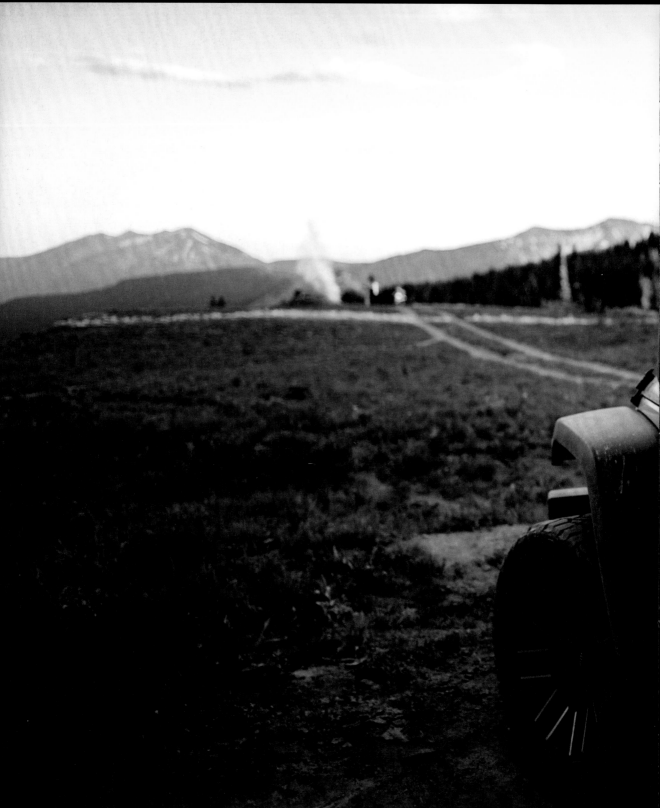

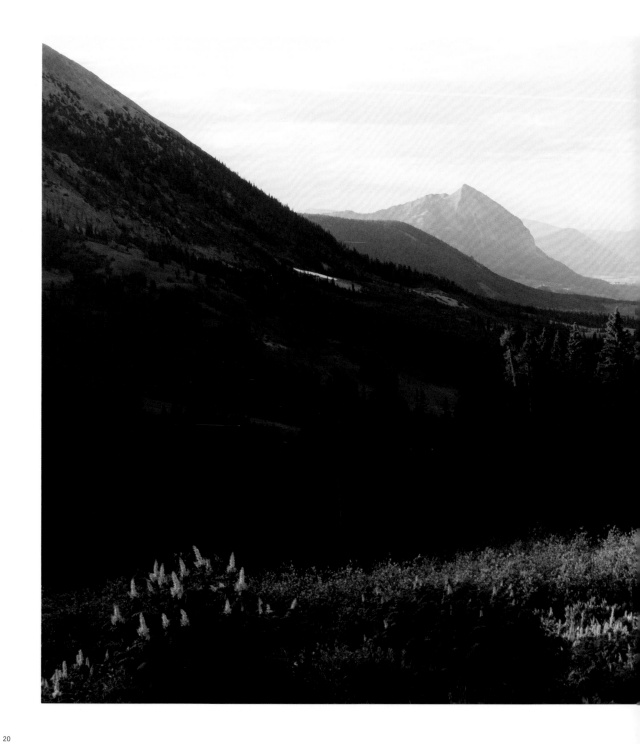

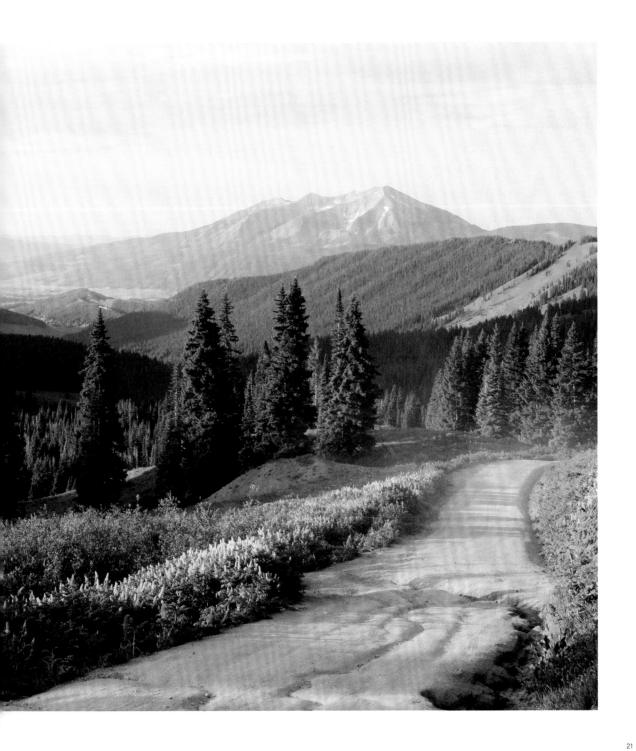

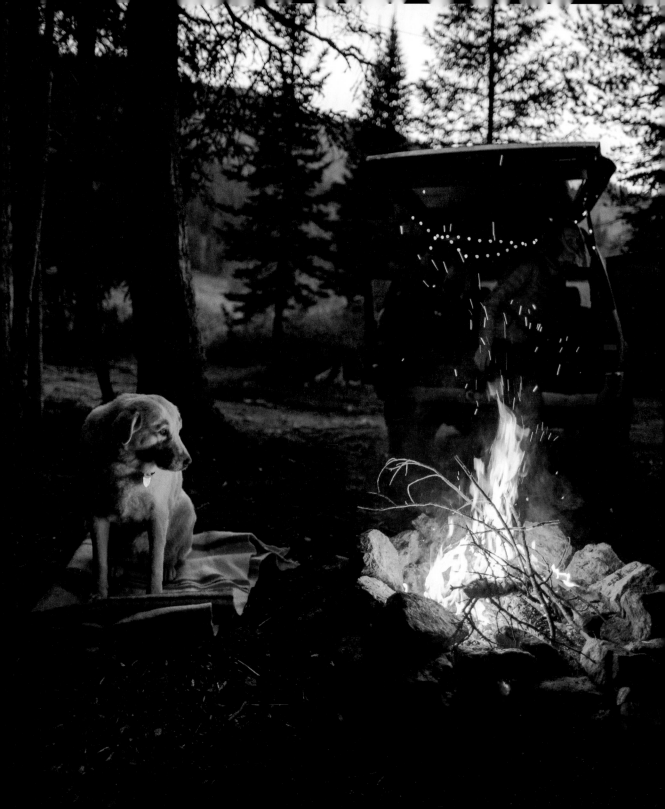

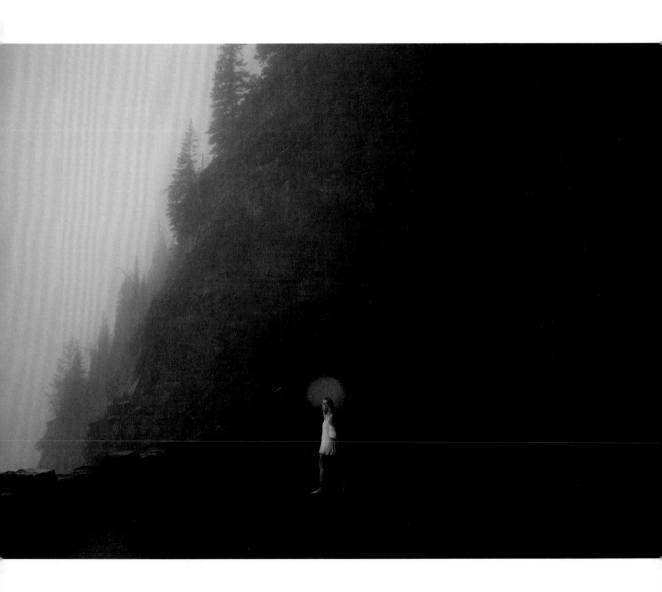

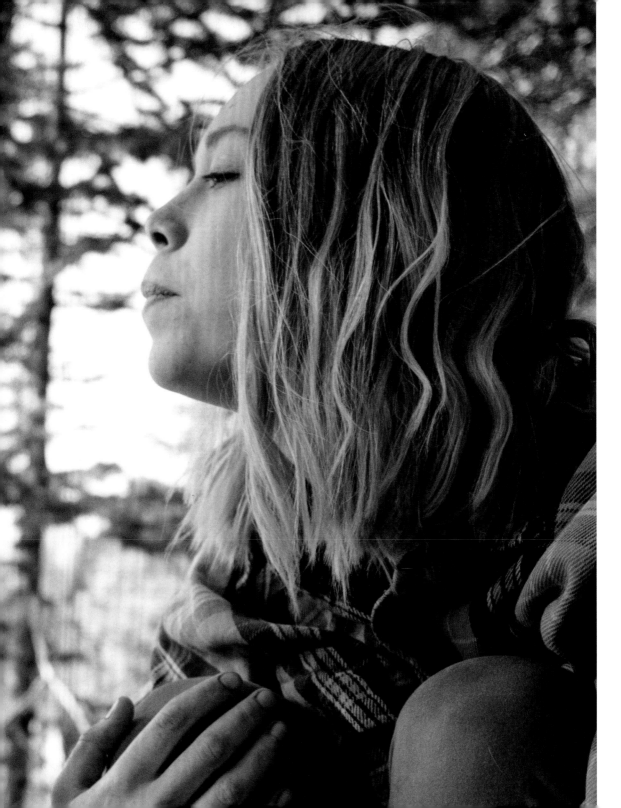

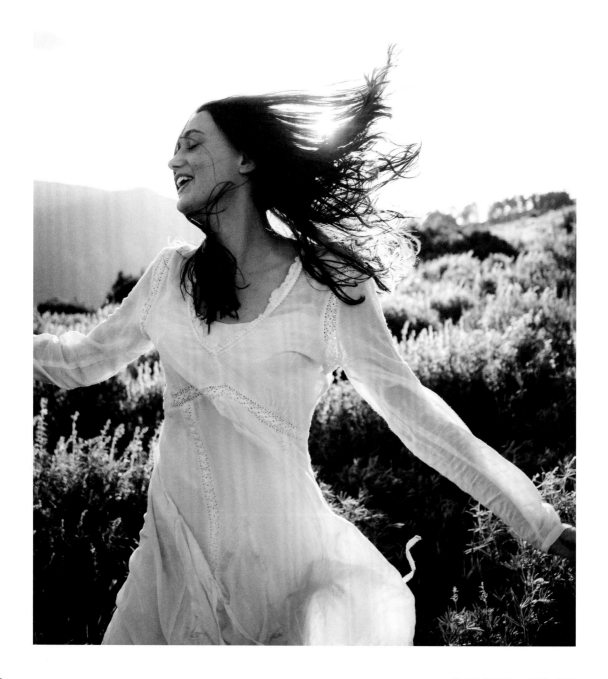

ELINA SMITH JULY—2016

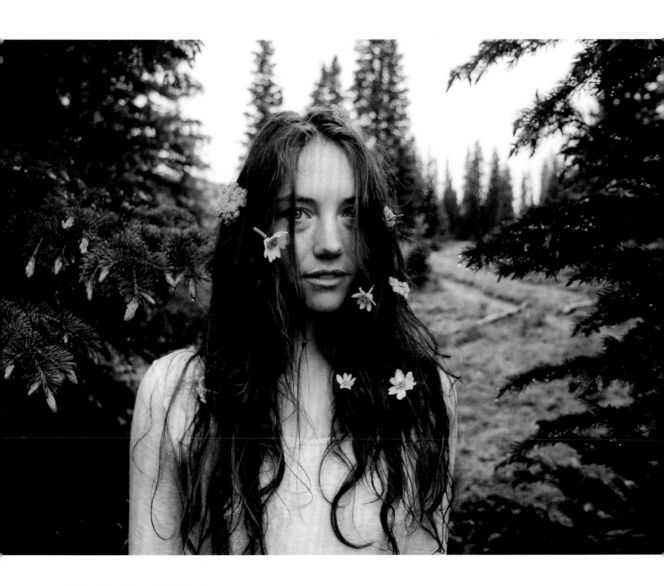

SHANNON MOLVIN JULY—2016

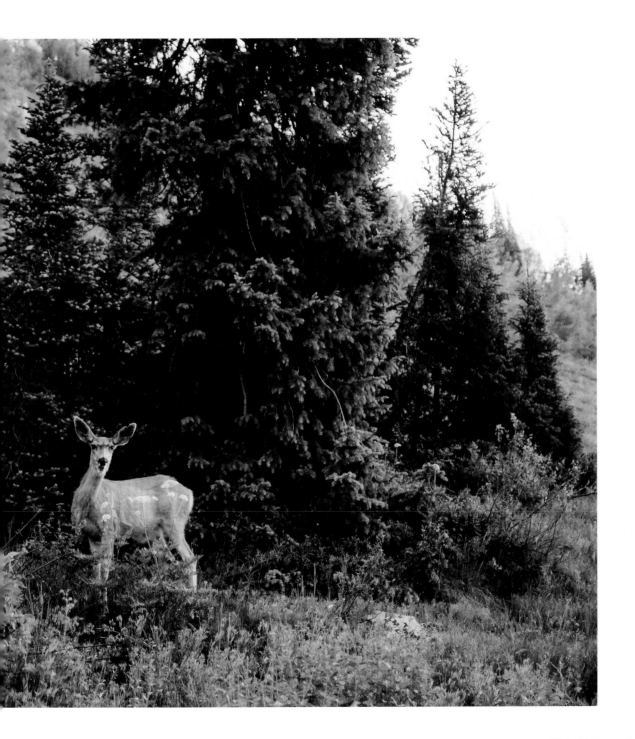

FLOWERS / ASPENS / ELINA

The way things disappear
(cease to be visible).
I haven't been here in a while.
I guess all hidden becomes visible once again
(cease to be visible).
There was something about these trees.
Silence.
There was something about these leaves.
Silence.
There was something about this air.
Silence—

A long time ago I came home.
It was in spaces I didn't recognize.
There was a feeling in the air that afternoon.
Something irreplaceable.
Irreplaceable.
A single breath in the woods that was felt
Deep deep deep.

I'm glad I found you again.

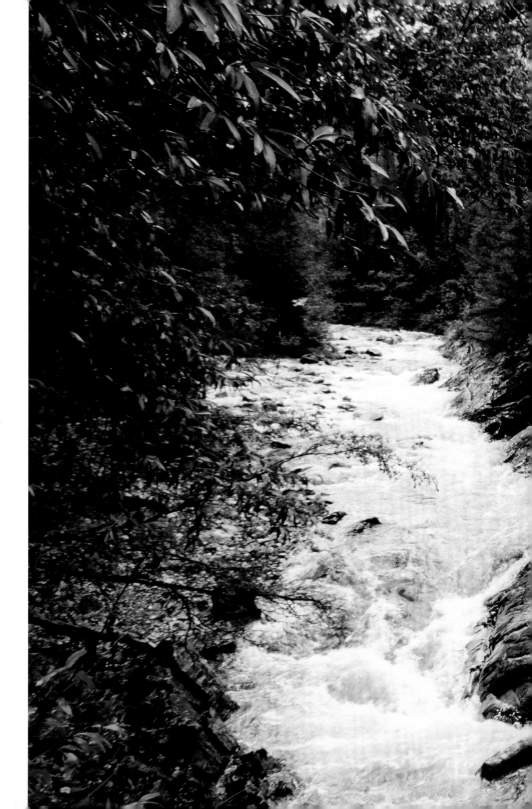

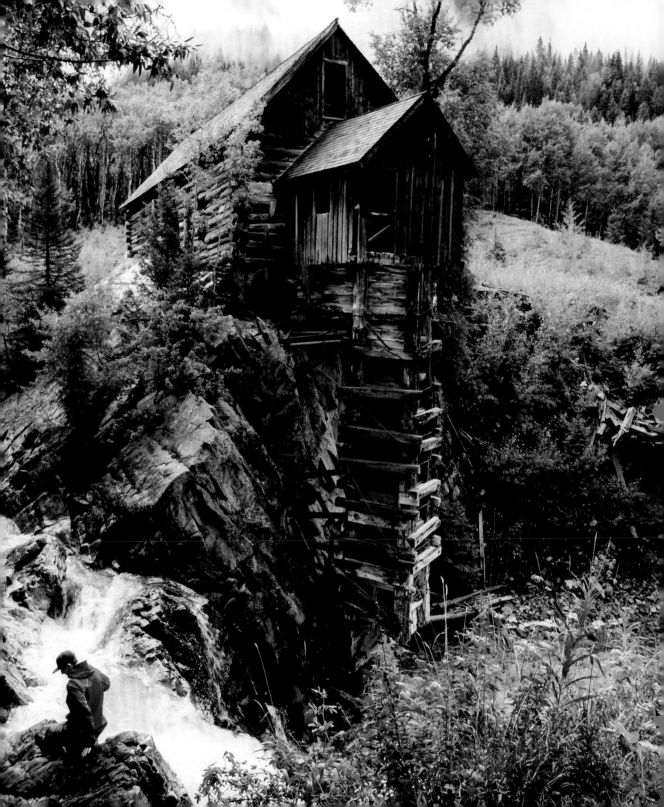

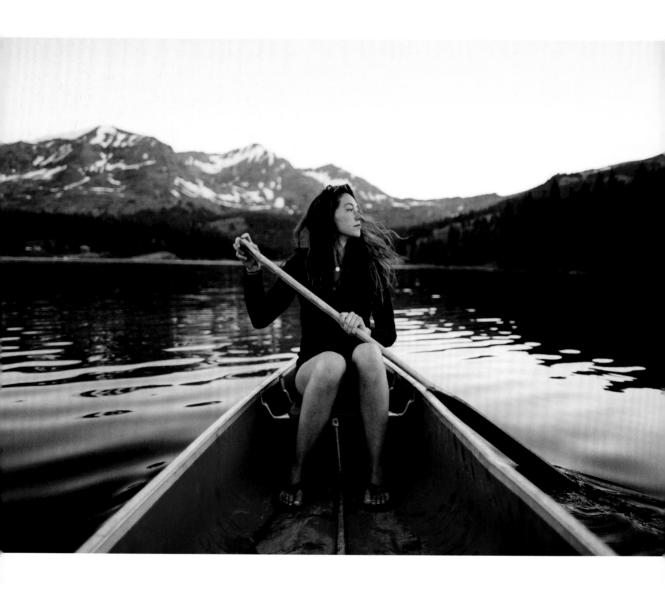

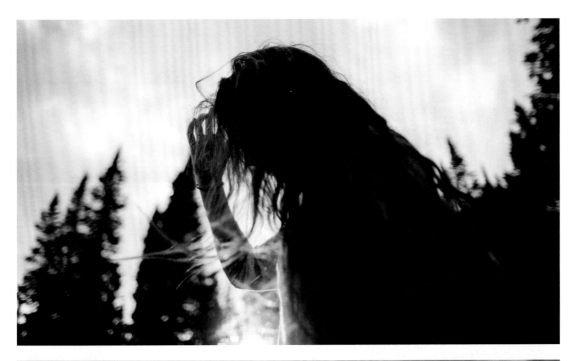

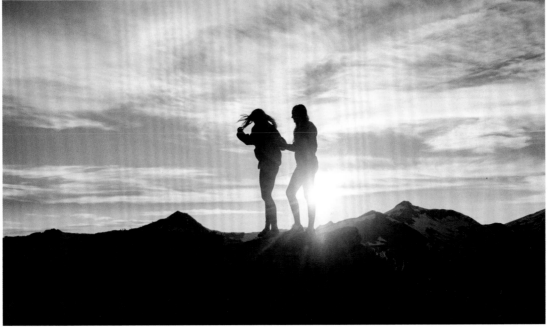

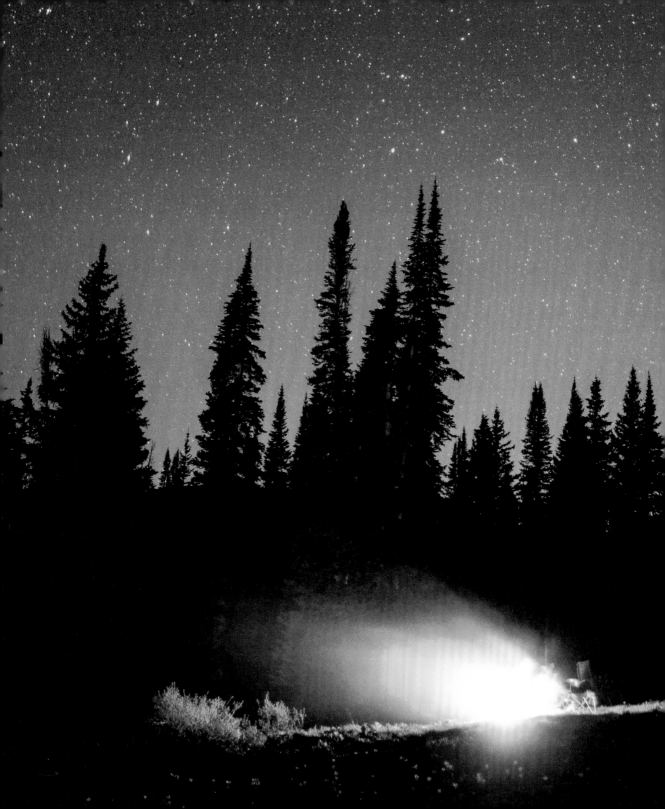

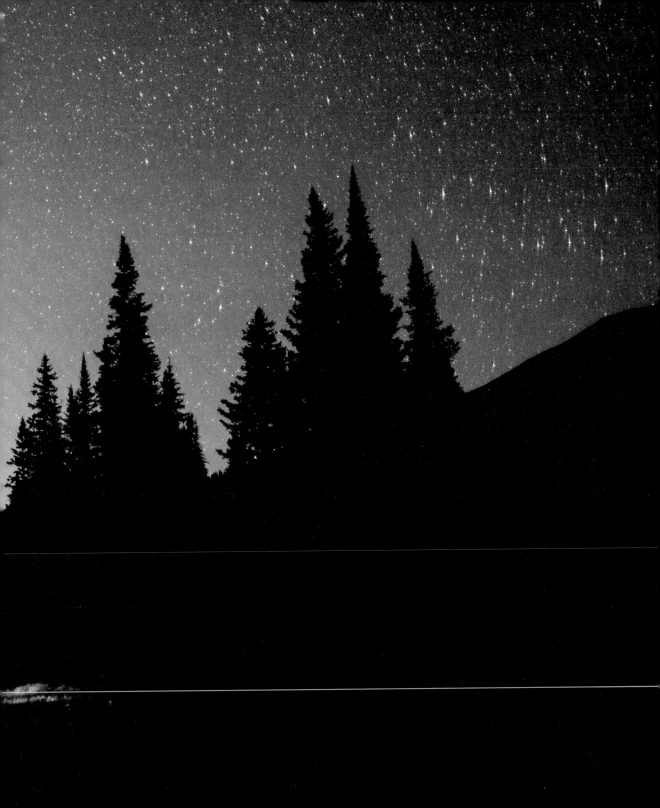

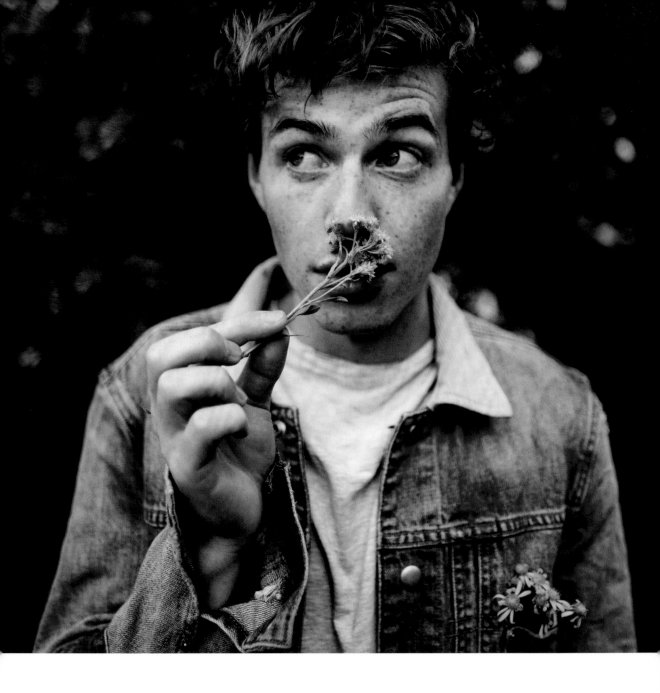

JOSHUAH MELNICK AUGUST—2017

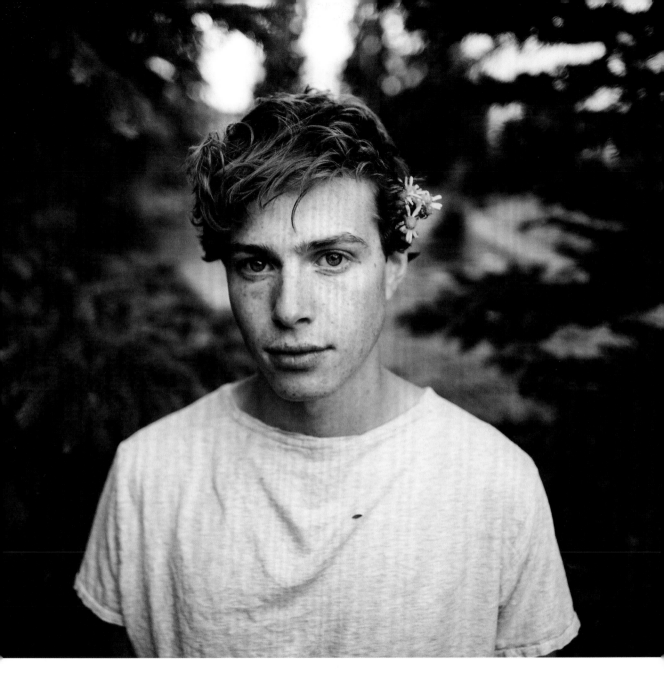

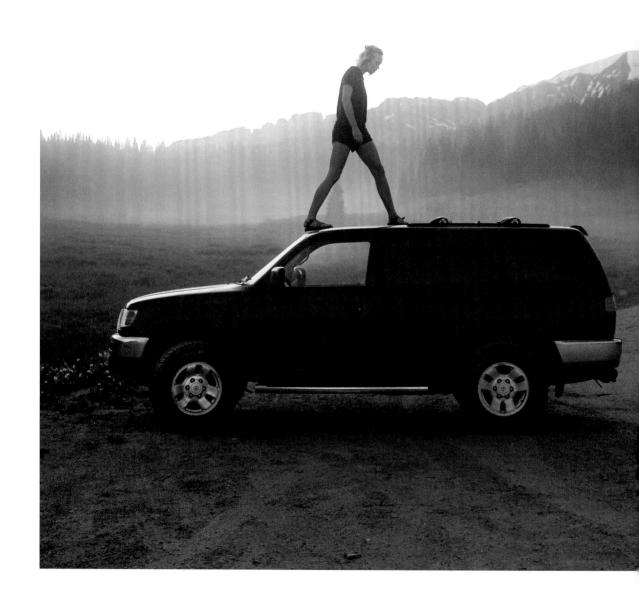

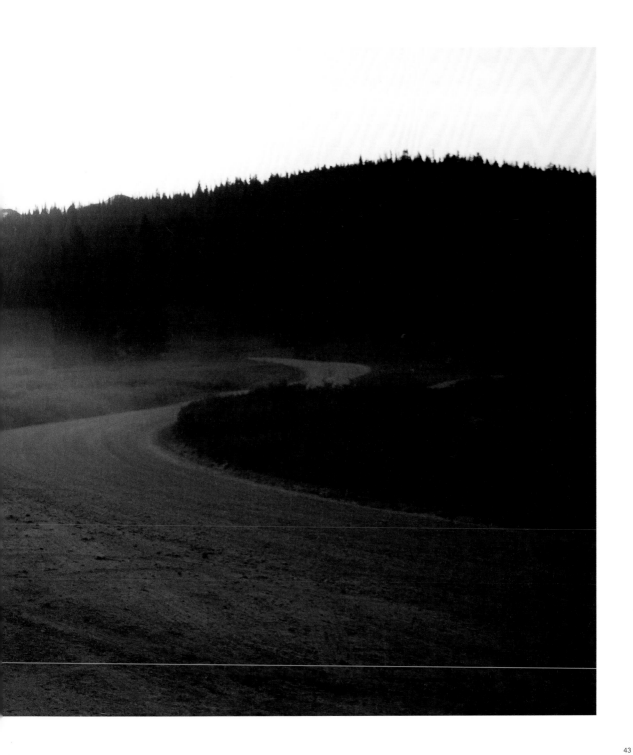

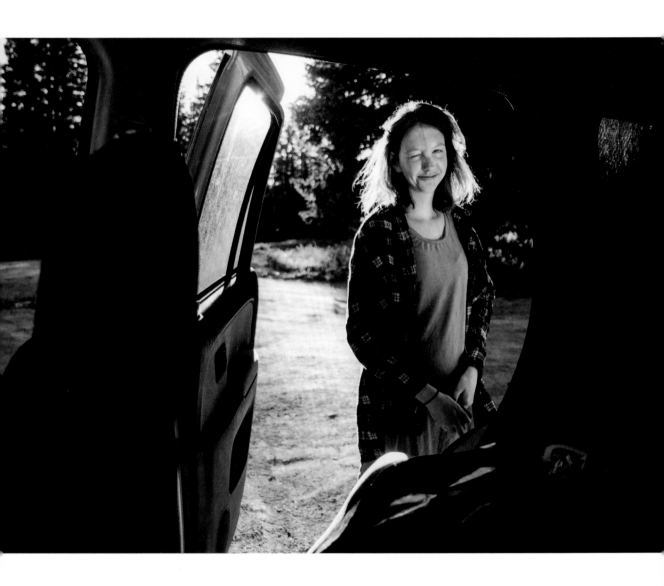

MOLLY MOLVIN JUNE—2016

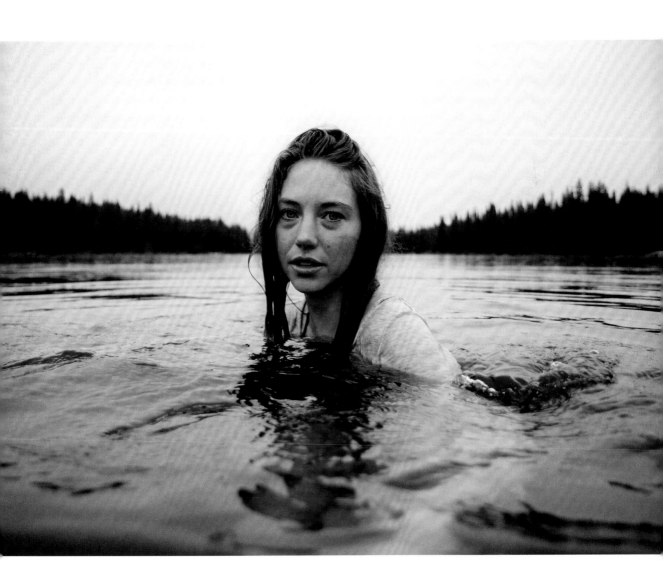

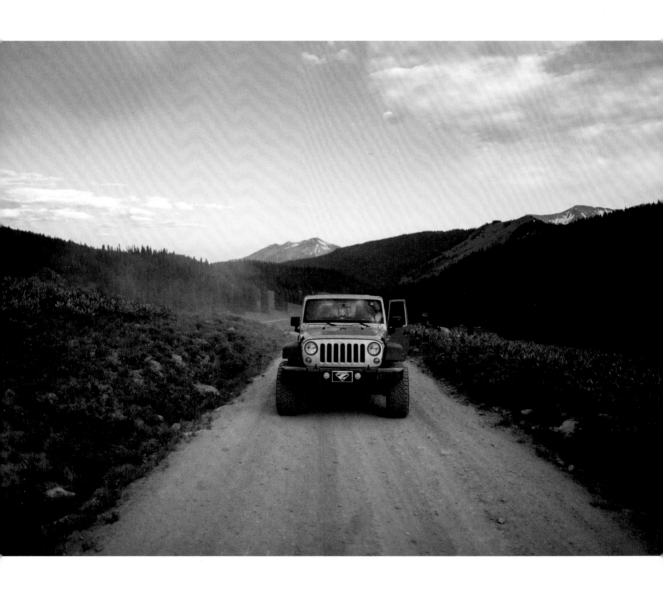

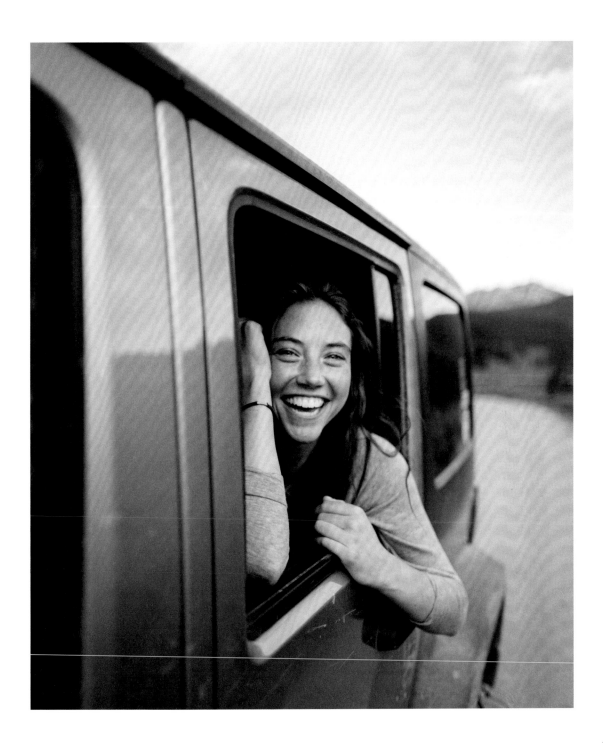

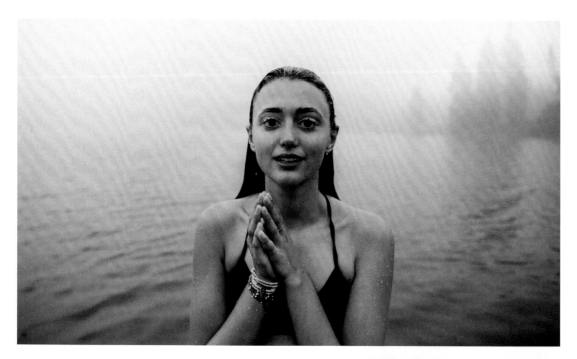

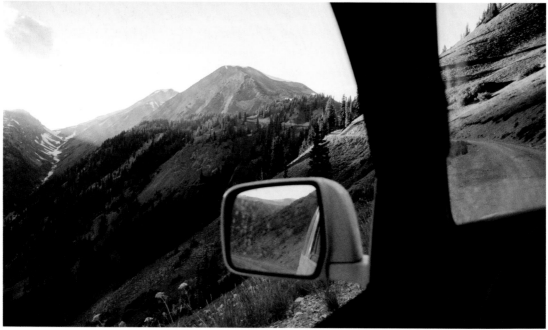

ELINA SMITH AUGUST—2017

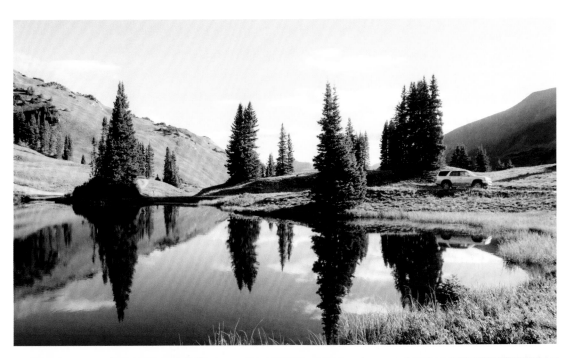

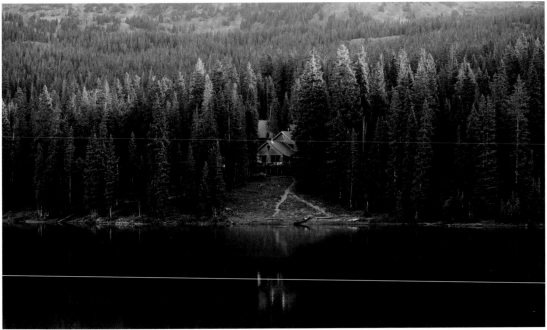

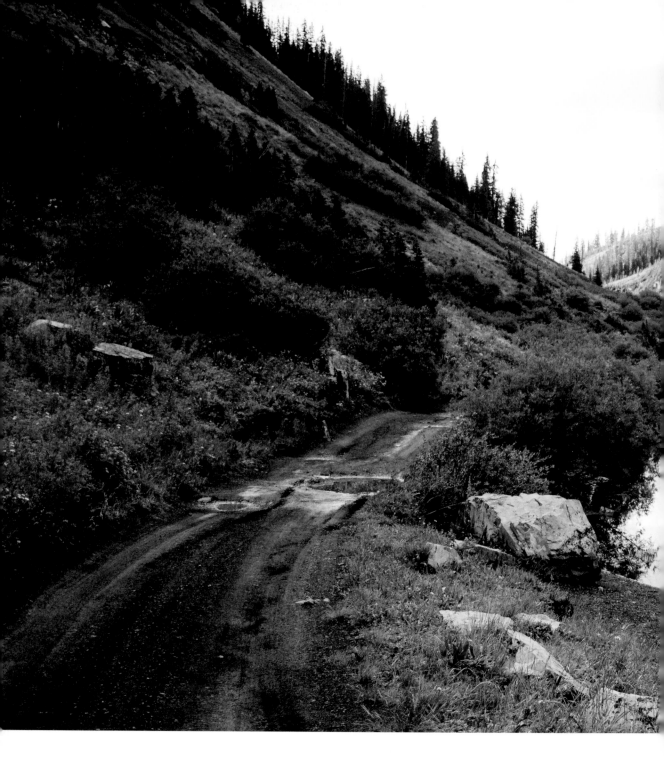

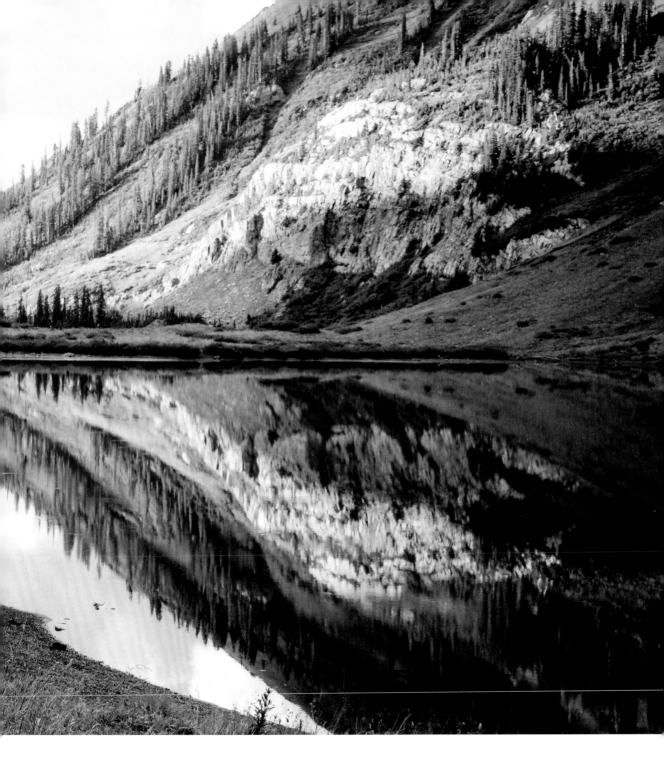

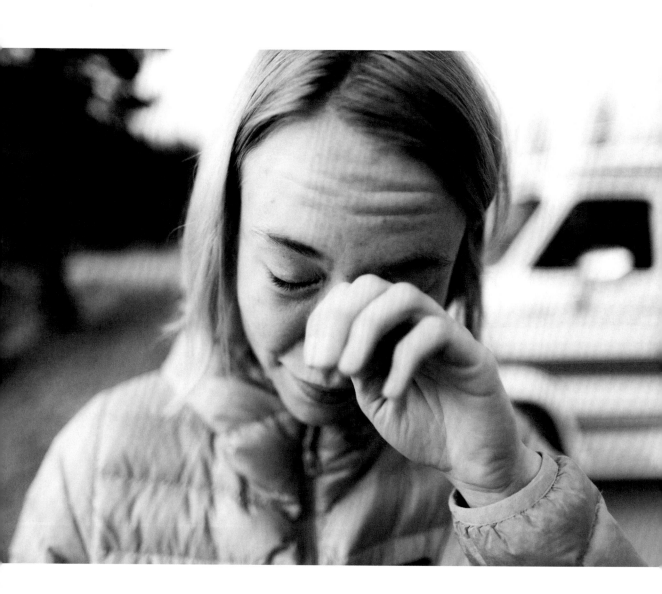

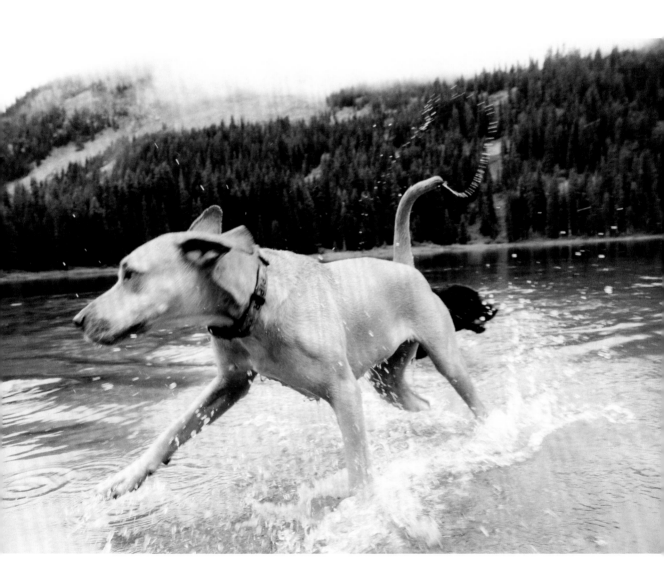

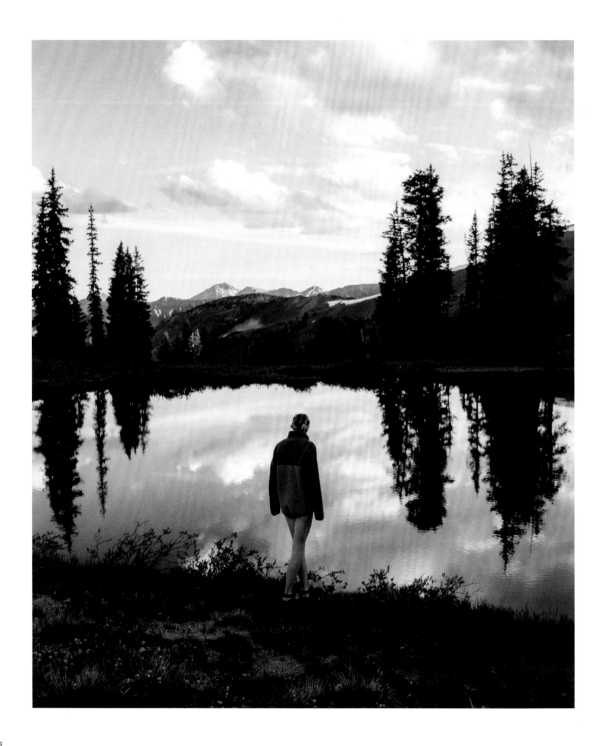

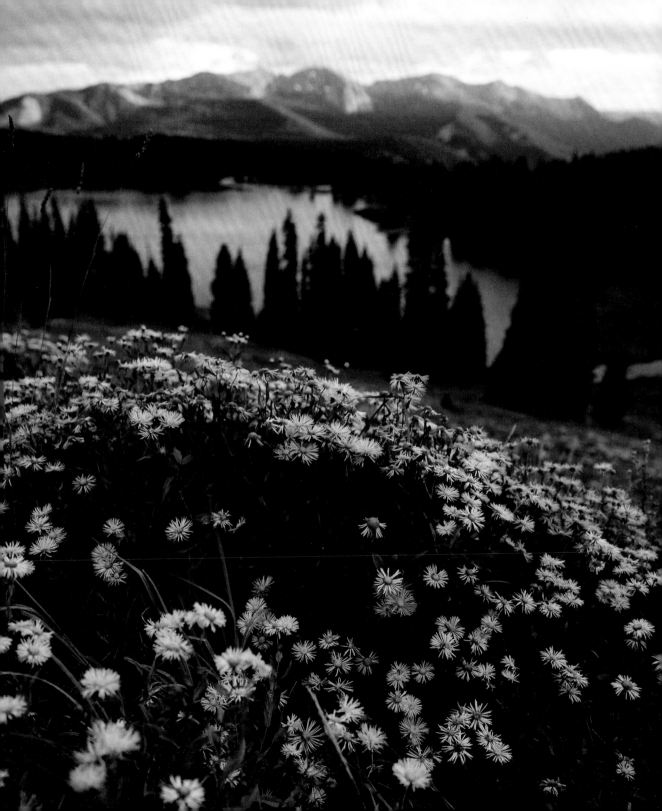

BYE

AUGUST 1ˢᵀ, 2019

I always feel like I need closure leaving this place. I never get it. Maybe that's a good thing; maybe that means my time here isn't over.

I fell in love. My life shifted. Truths I found to be self-evident disintegrated like sand.

Maybe it isn't over.
Maybe it isn't over.
Maybe it isn't over.

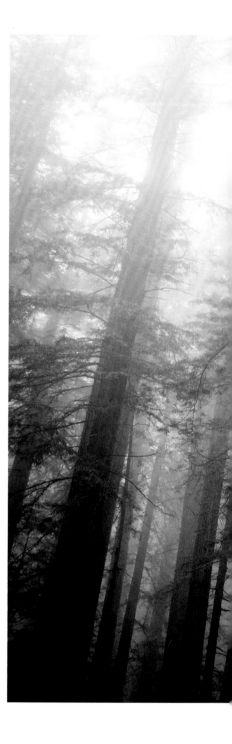

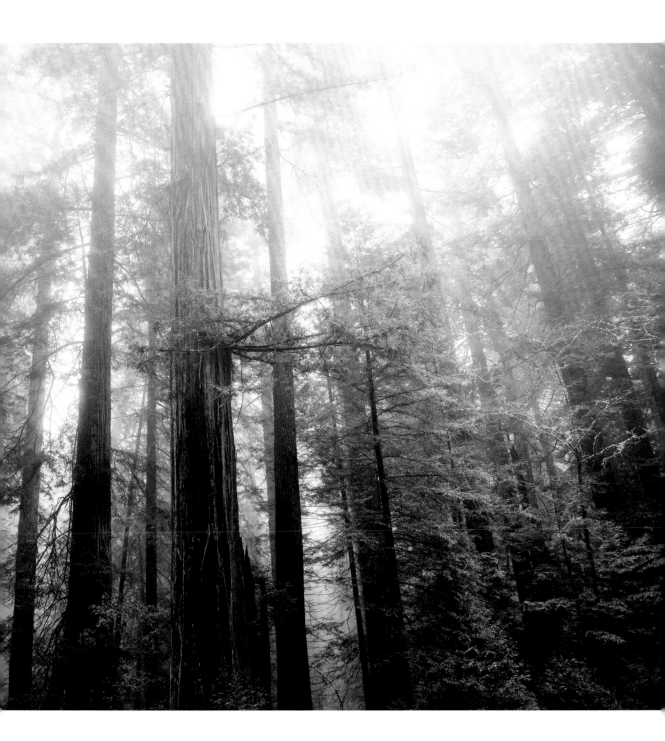

A while ago, someone described the idea of "Thin Spaces" to me. "Thin Spaces" are places in the world—experiences, moments, whatever it may be—where the barrier between heaven and earth narrows. A moment where whatever lies in the great beyond touches your experience. Somewhere between dreams and reality, heaven and earth, we find ourselves in these moments... if we're lucky enough.

Finding "Thin Spaces" not only became a reason for me to live, but it also came to define what it truly meant for me to be alive. There have been moments along my journey where I've found myself in places I never thought existed beyond fantasy, feeling emotions I never experienced before. Close to heaven, with my feet firmly on the ground, I shared moments with those I loved around me. These experiences taught me to love the world, to love others, and how to find love in myself as well. To venture out is to truly know oneself better. Experiences transform into memories, and this is how we come to know and understand our world. In a way, what draws me to these spaces is a curiosity about the world as much as myself.

It would be cliché to compare the places I've been to heaven in any way, but because of these places, I know something else exists beyond them. The wilderness of the American West is one of these places. This frontier became the backdrop of my youth; running free in open space, we came to find ourselves. Somewhere between the stars and solid ground—between heaven and earth—we found life. Not merely by breathing, but by being resolutely alive.

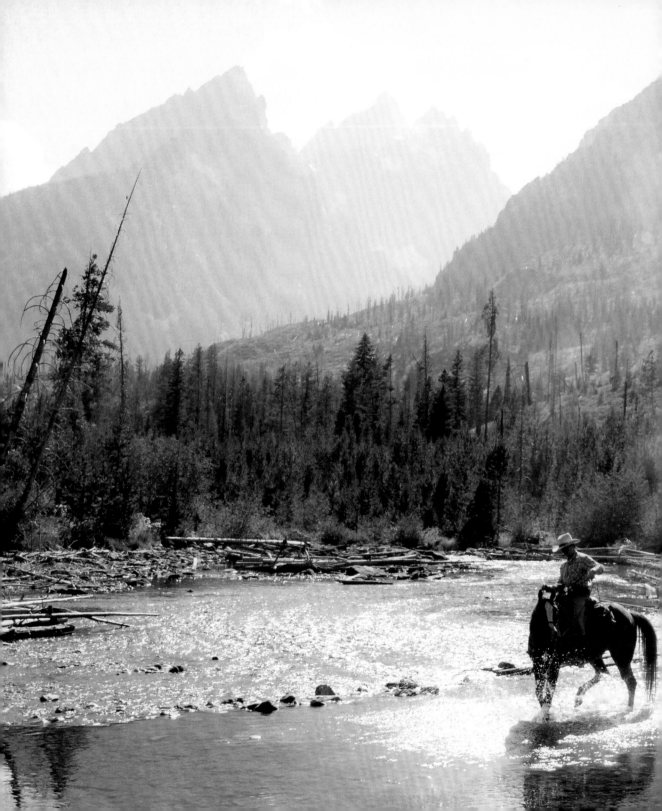

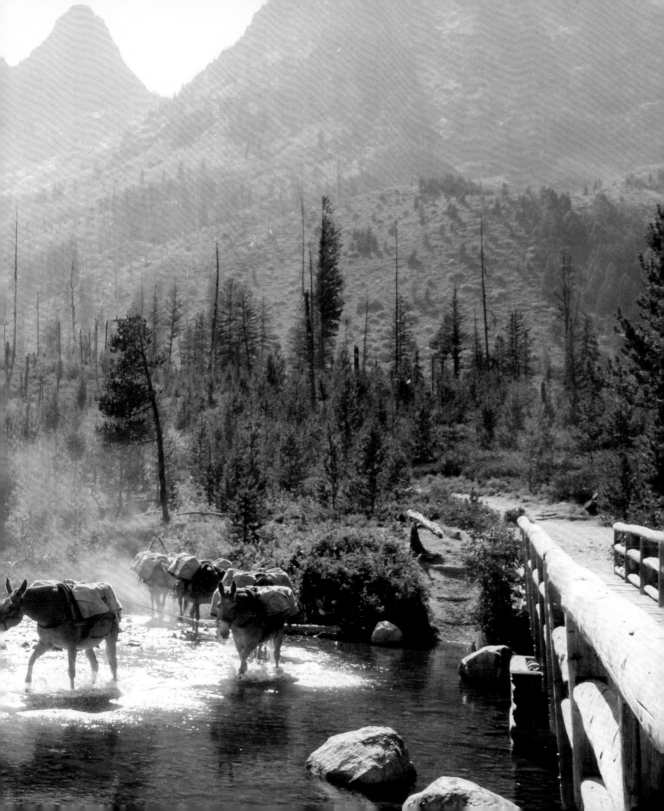

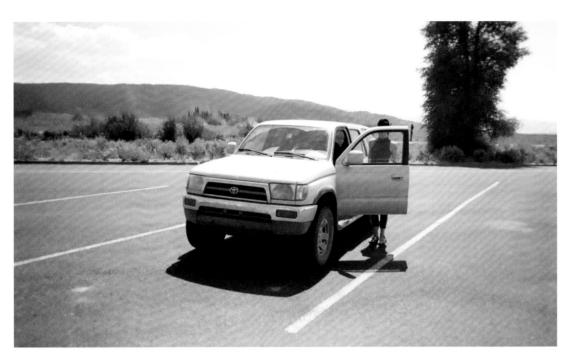

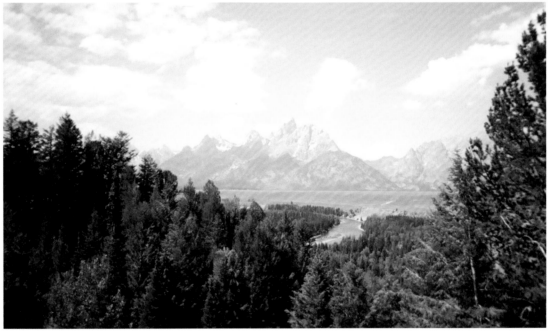

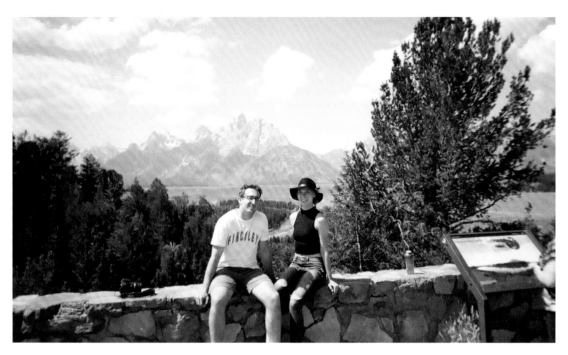

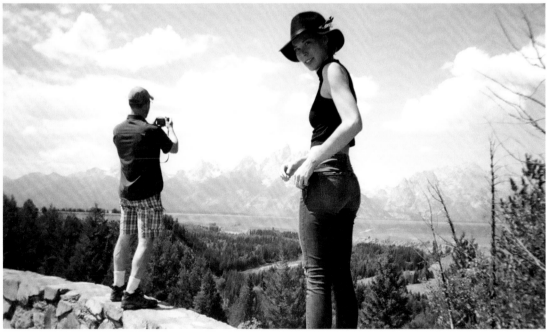

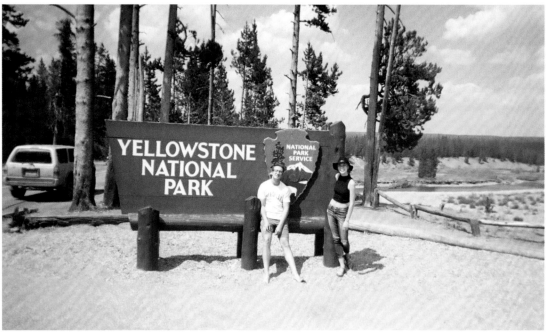

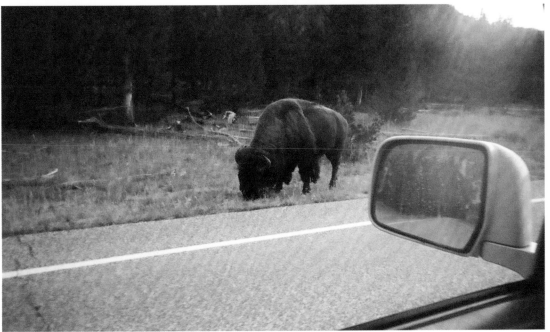

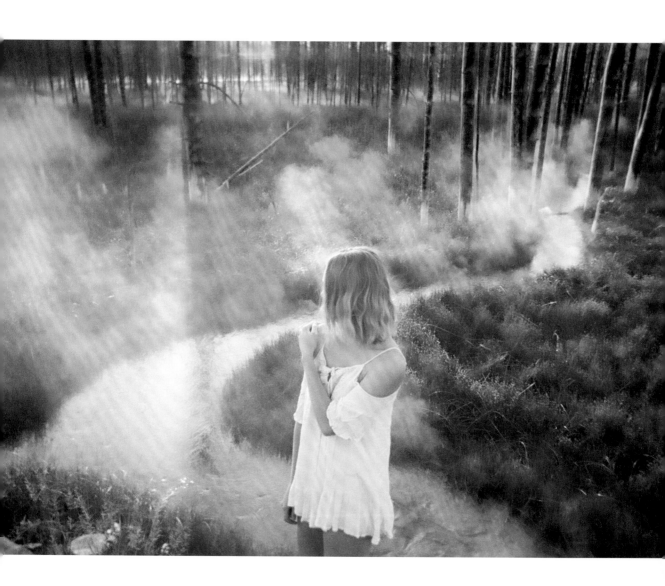

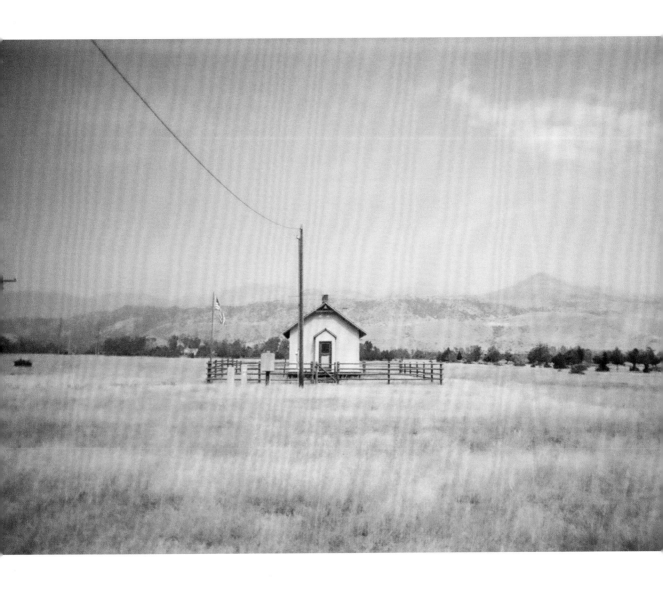

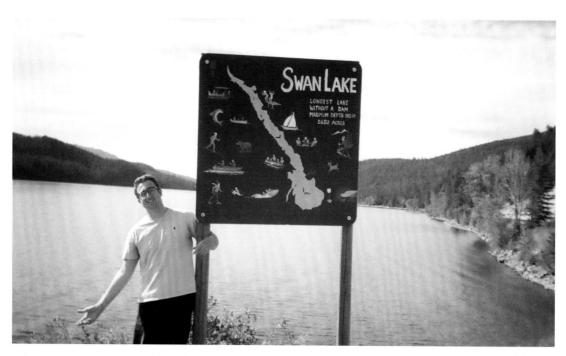

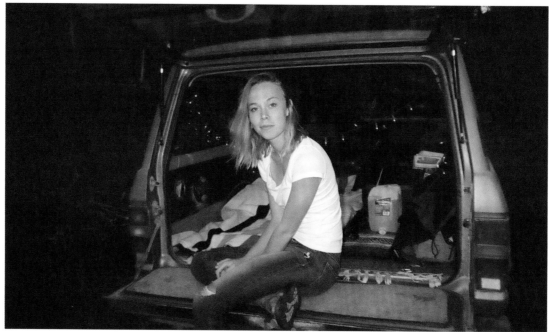

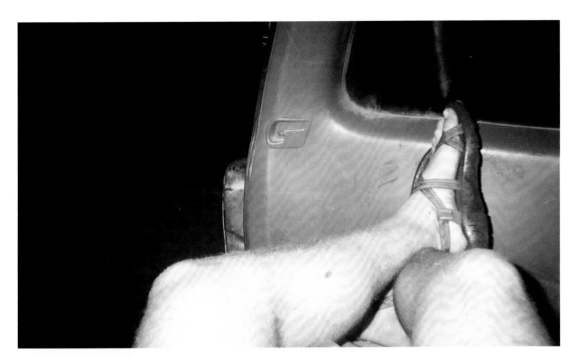

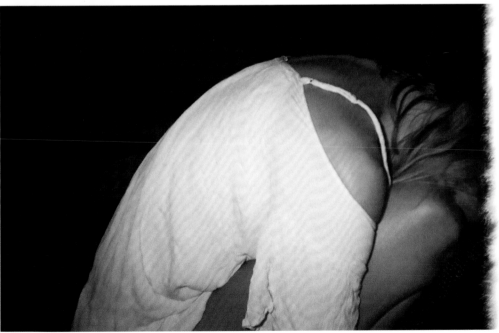

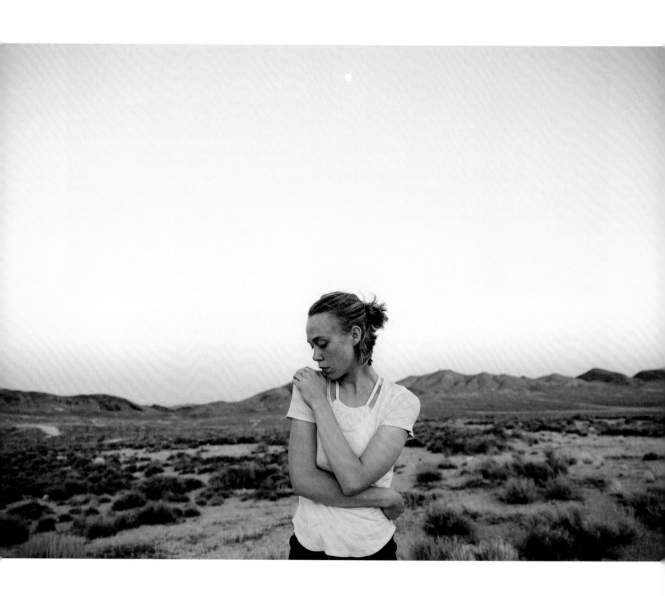

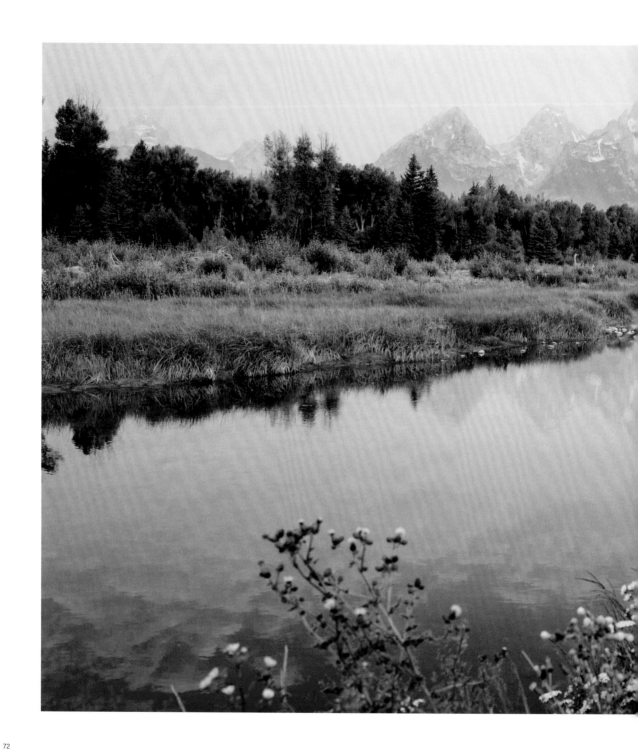

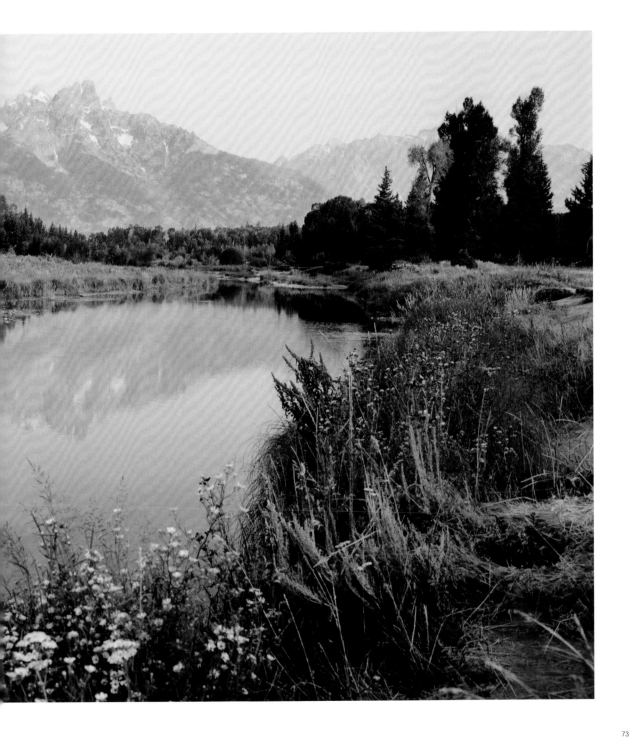

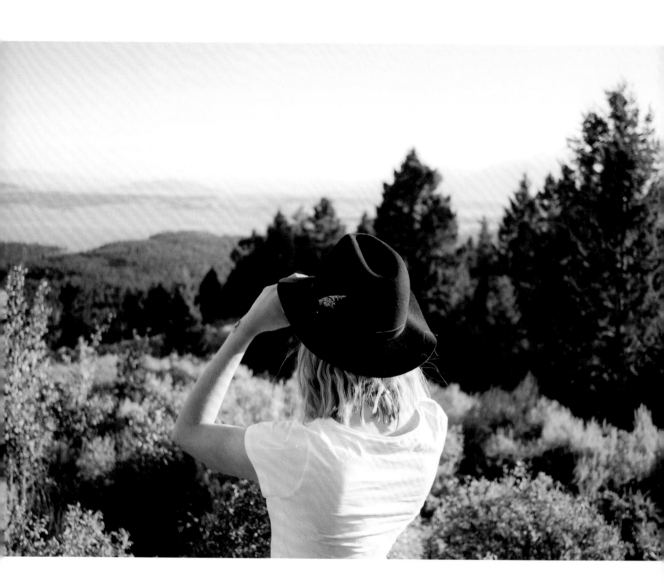

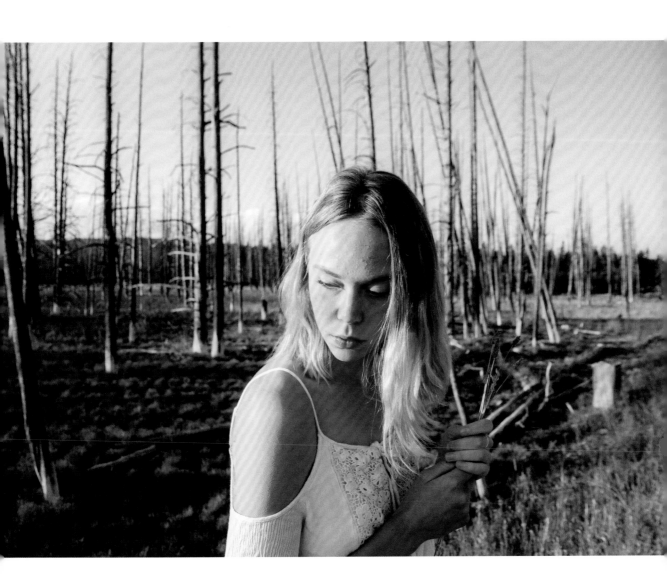

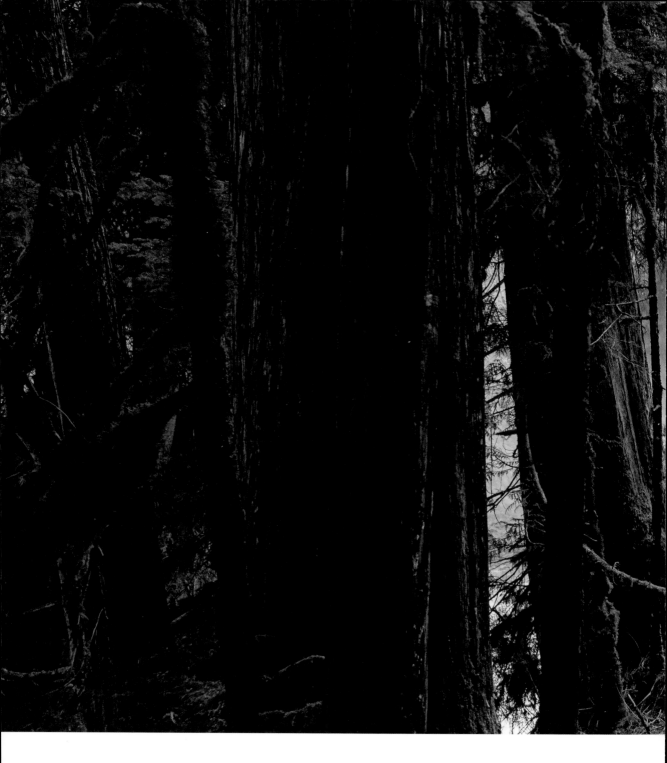

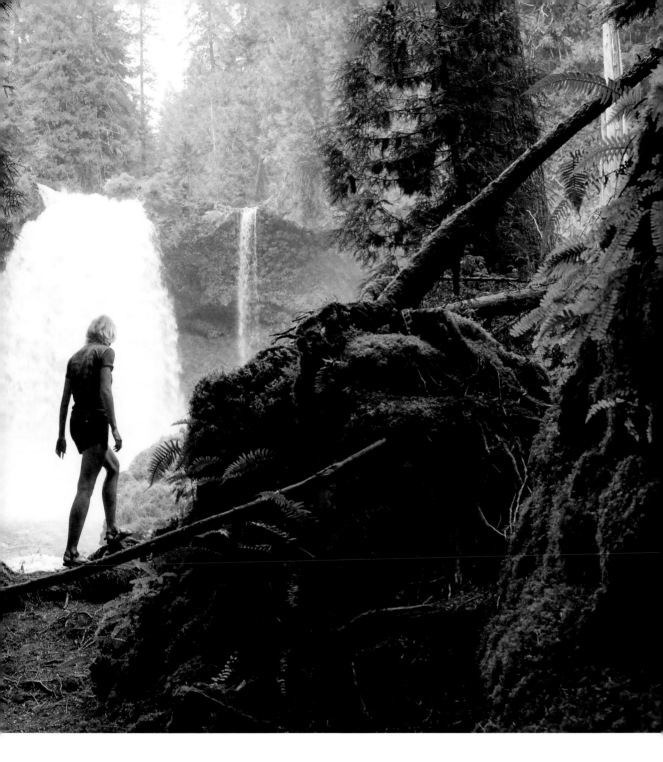

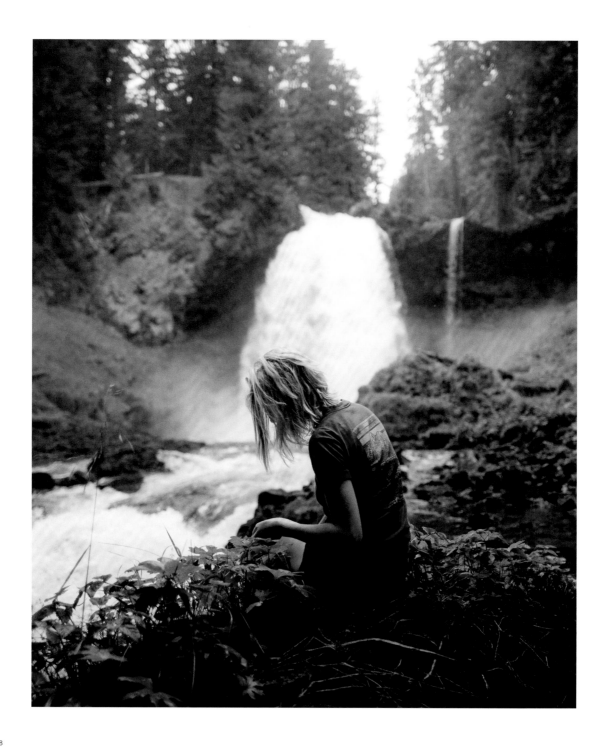

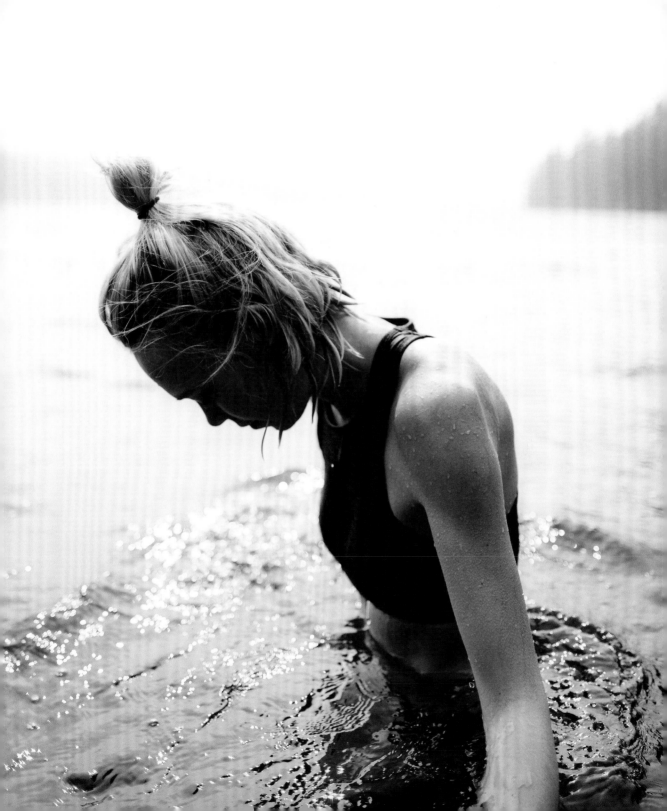

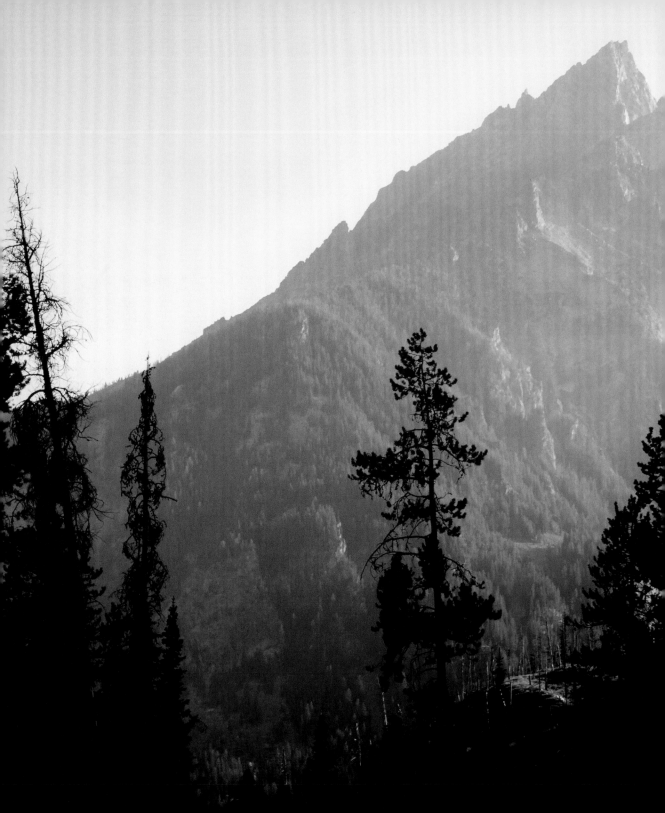

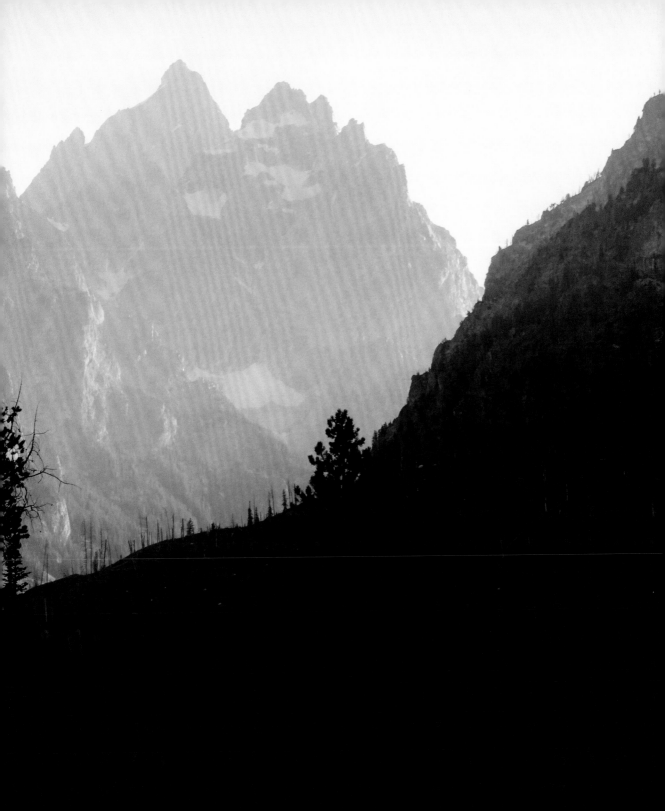

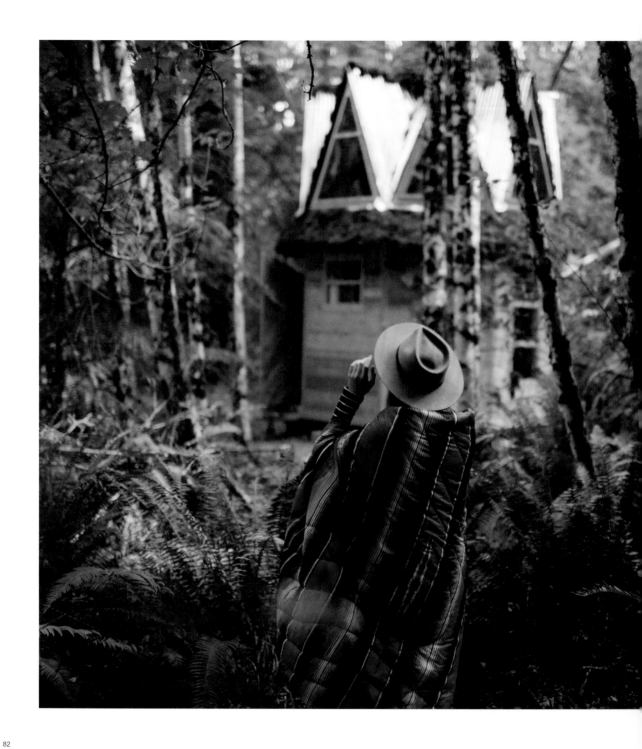

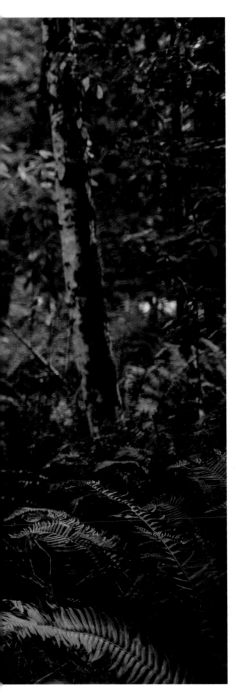

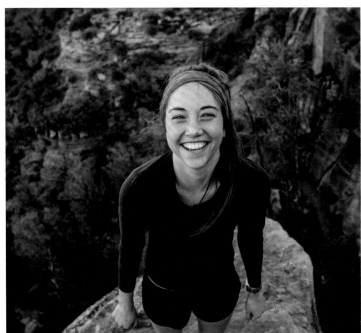

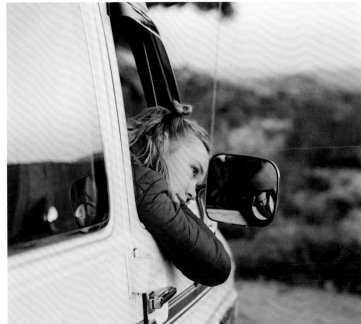

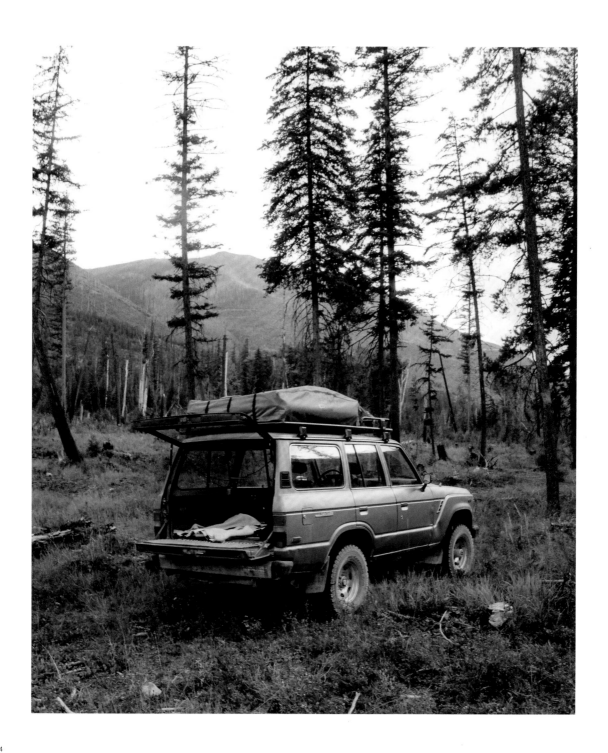

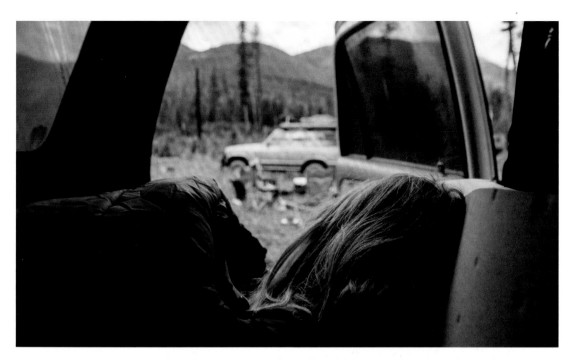

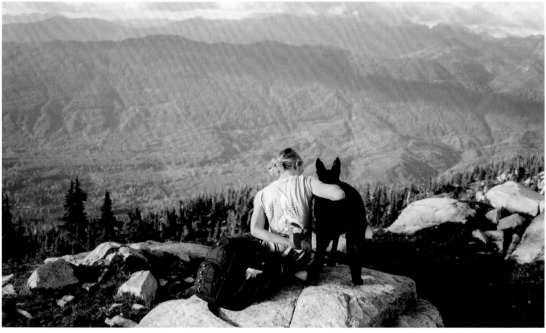

MONTANA AUGUST—2016

AUGUST 6TH, 2019 AT 9:02 PM

Rainer, on the hood of your car,
the sky was pink and blue.

When I was 22...

I was blessed enough to travel the world.
I didn't sit still for very long at a time. I watched a lot of
sunsets, I watched a few sunrises. I battled vices that
I thought were set to destroy me,
I found the value of family, friends, and little talks. I visited
places dark, and I frequented places of light. I was heartbroken
and numb, I found a love that was impossible to explain.

When I was 22 I was the most lost I've ever been and I
simultaneously learned to walk with faith.
I learned to listen and speak with a soft voice,
I learned to watch the moon wane and wax.
I had sober nights, drunken nights, nights filled with
sorrow, and nights filled with laughter. I thought I knew
what I wanted, I thought I knew best. I did not.

When I was 22, I fell apart. When I was 22, I found my way.
When I was 22, I watched the universe end in front of me
and I found a reason to put mine back together.

Growth often comes with pain. For every seed planted, you first
have to dig through dirt. The anxiety of the unknown pairs well with
the freedom it affords. Through it all, we persevere with passion.

Wherever the world may lead you, to whatever lies ahead, find
peace in knowing this.

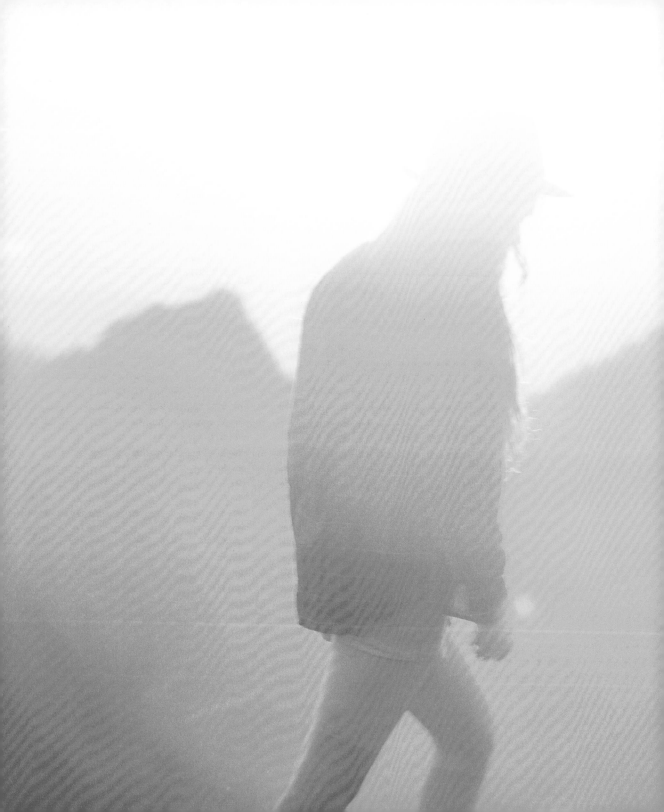

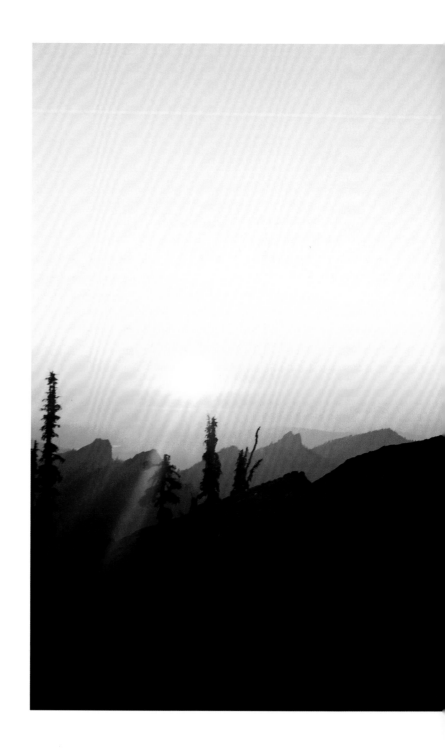

WASHINGTON
BAYLEY JUNES AUGUST—2018

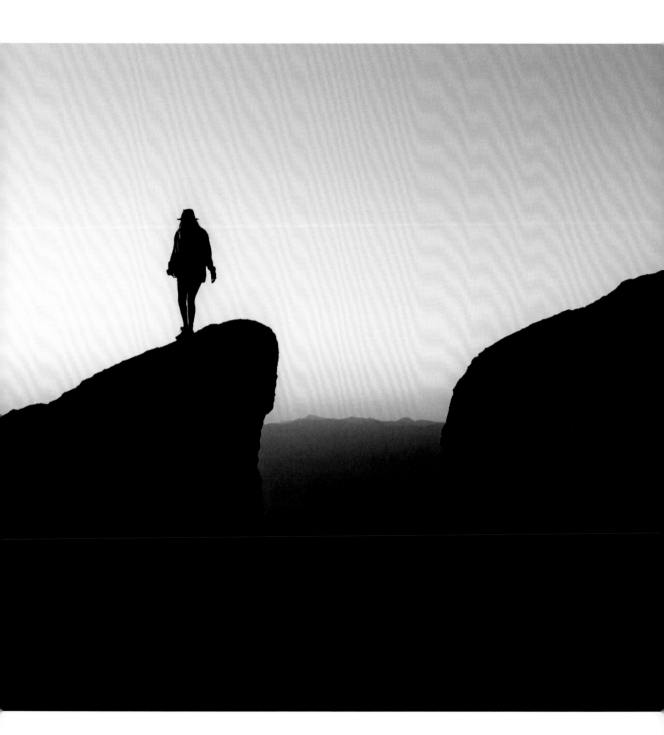

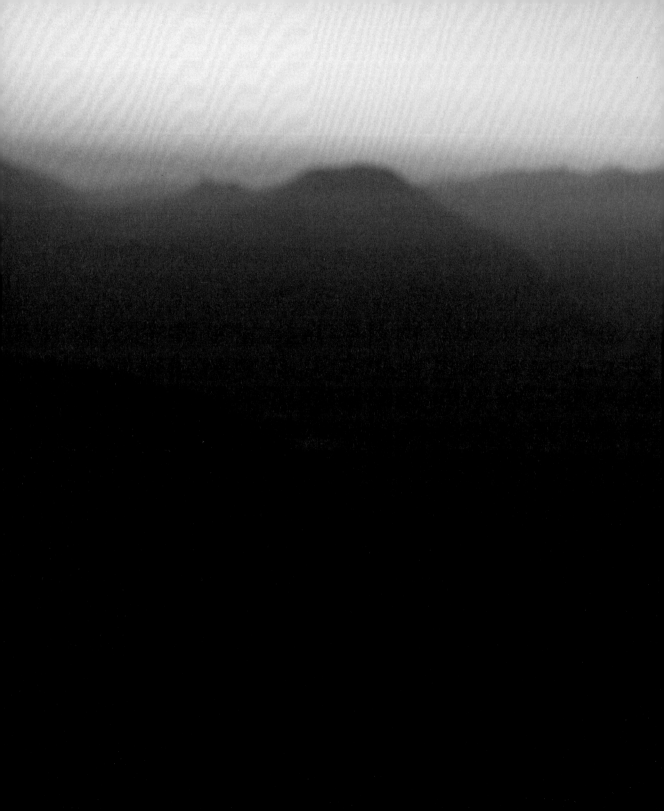

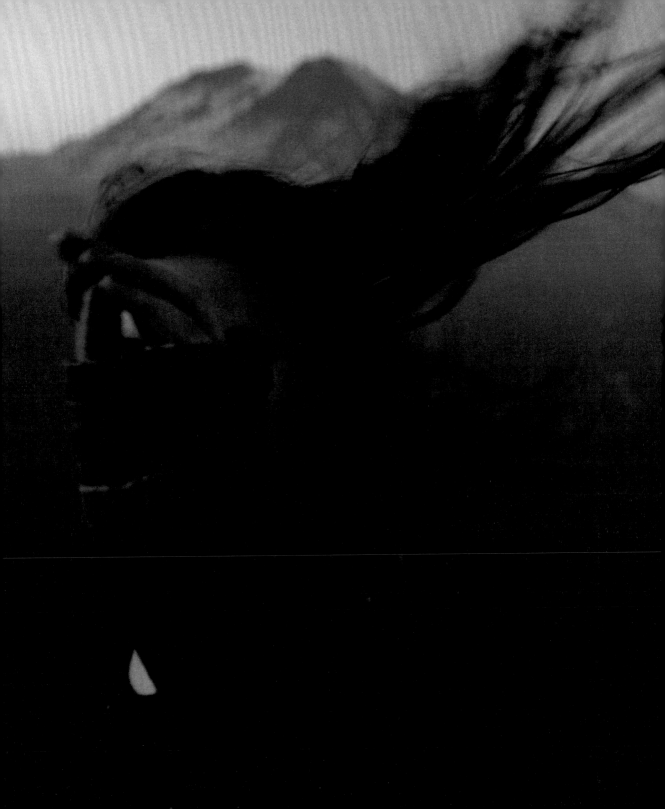

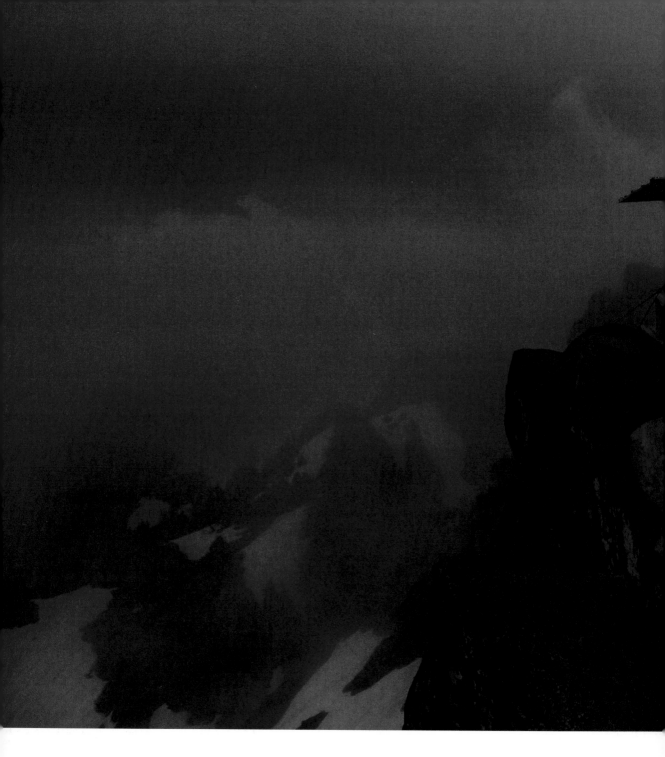

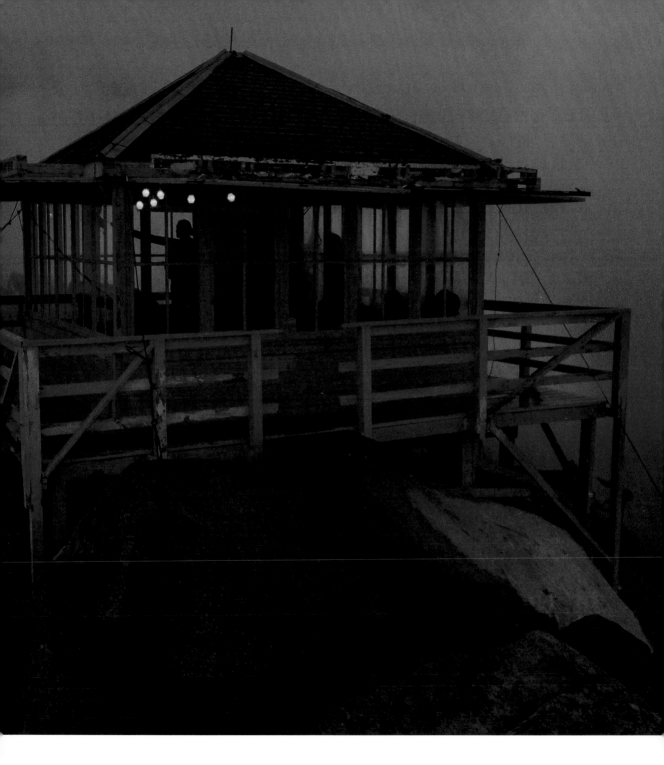

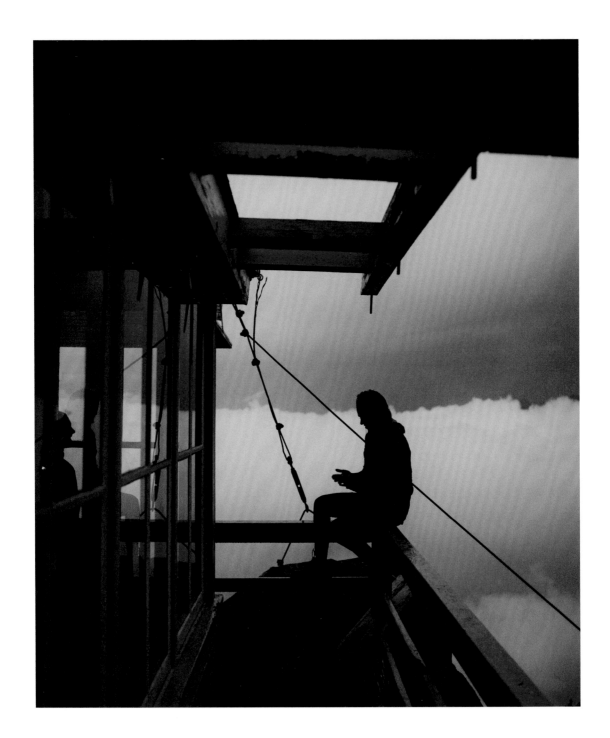

WASHINGTON JULY—2018

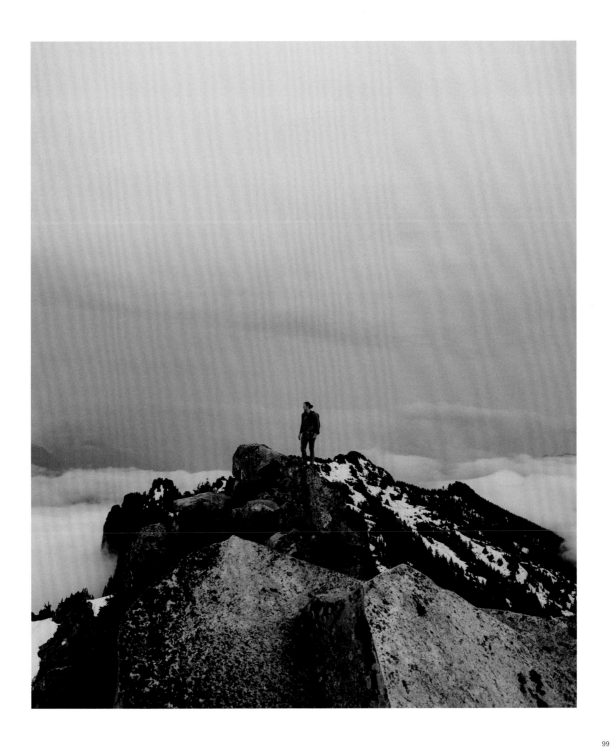

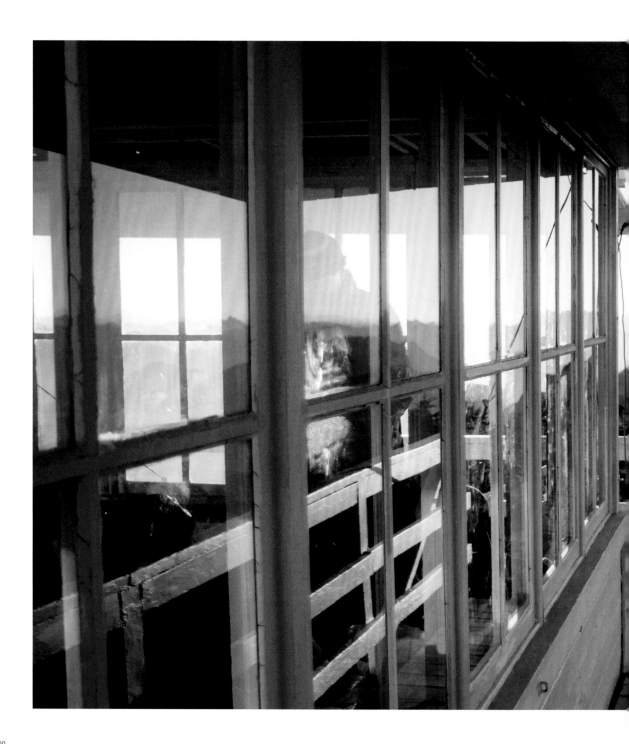

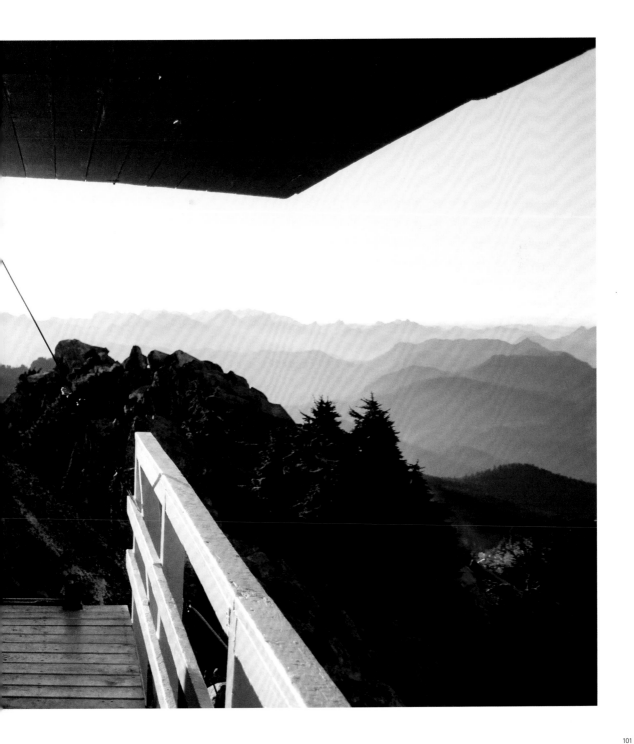

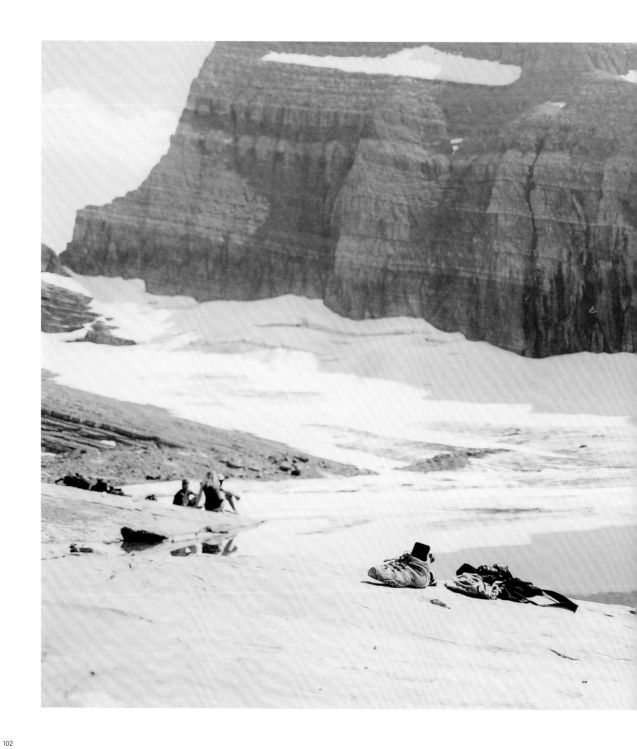

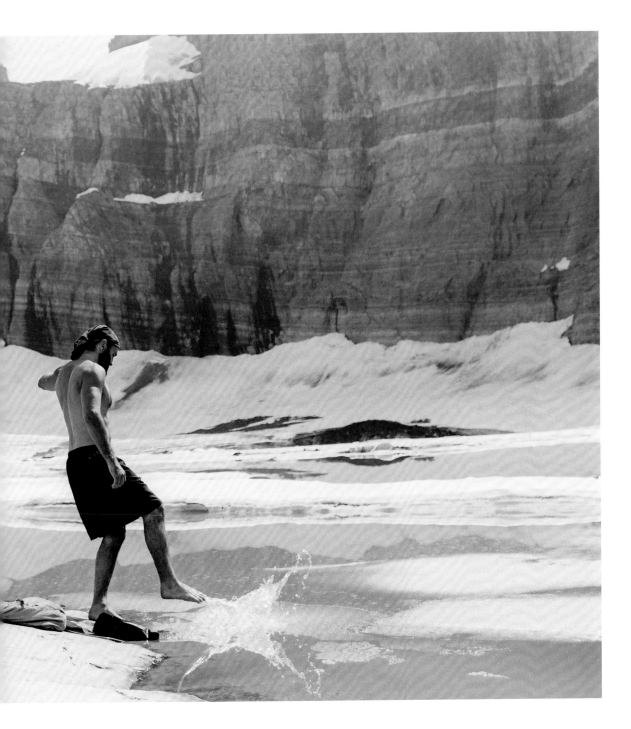

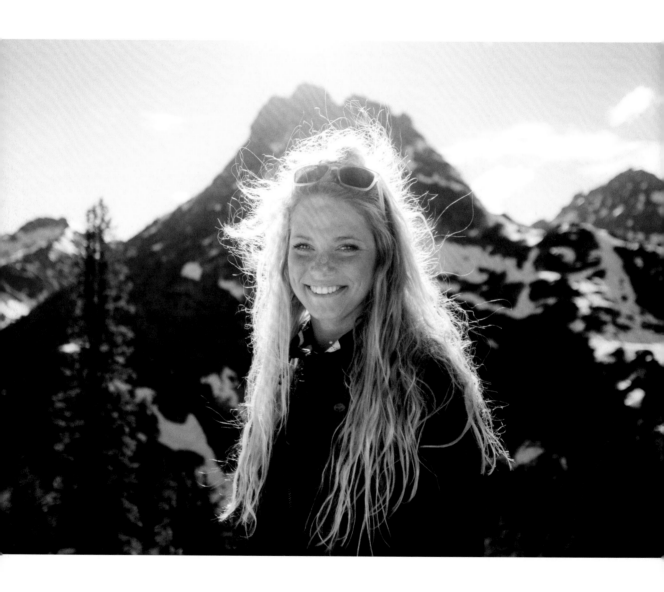

WASHINGTON
GABRIELLE NELSON AUGUST—2018

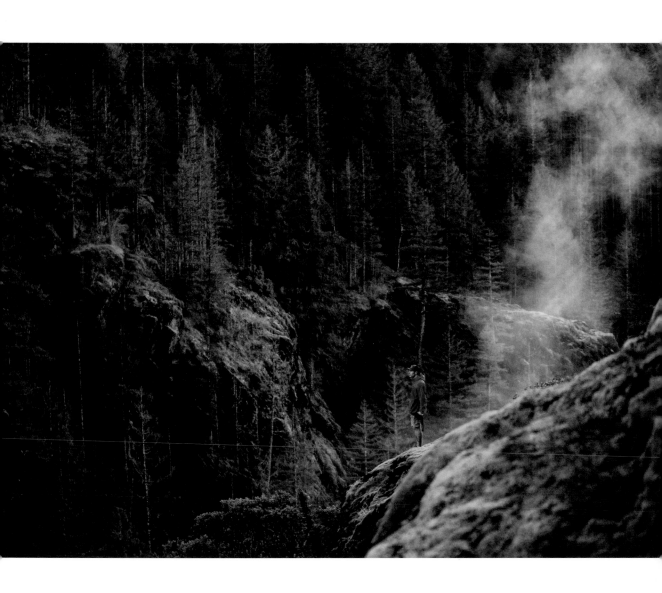

OREGON
CALEB WALLACE MAY—2018

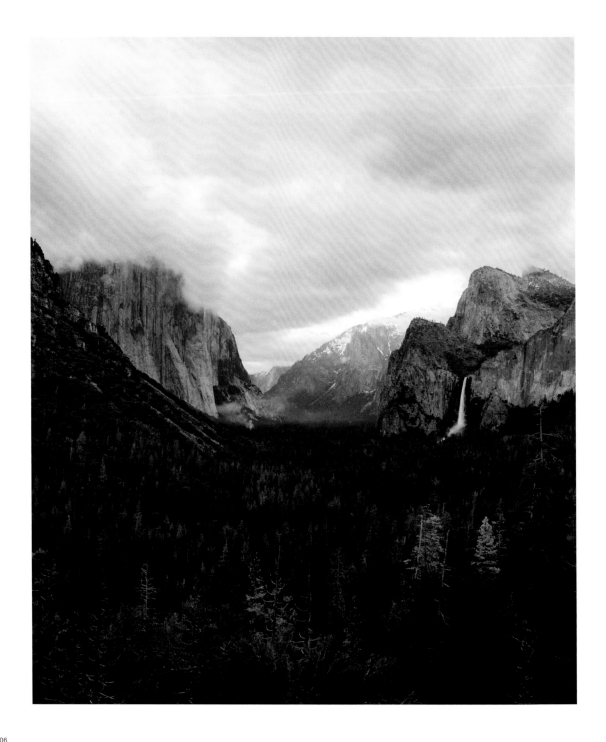

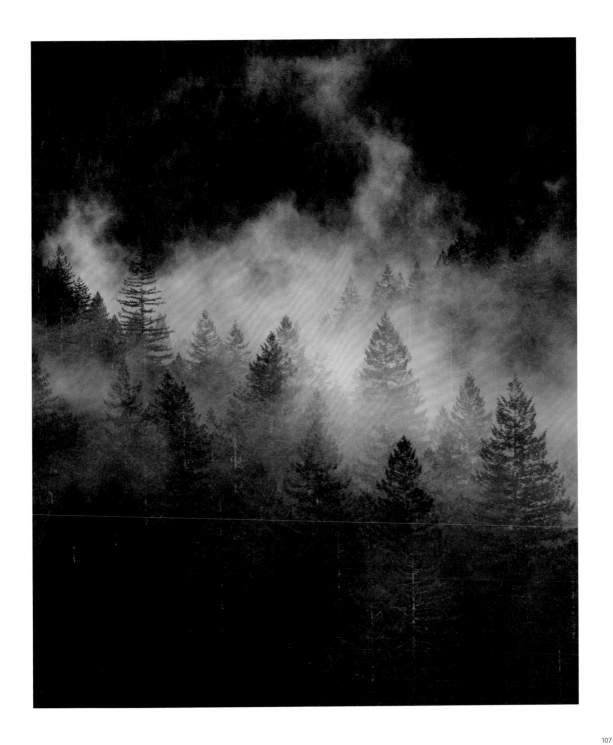

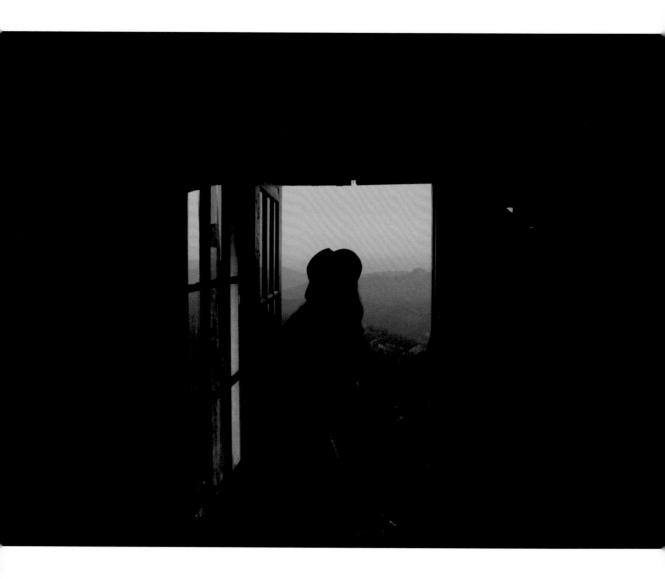

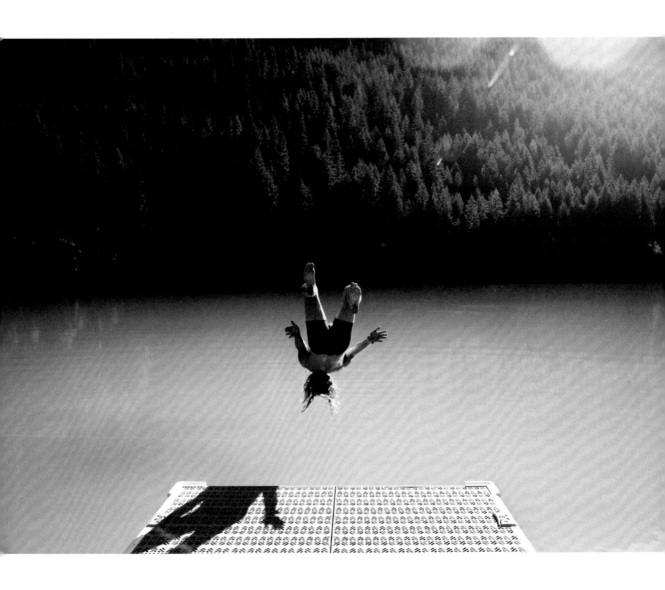

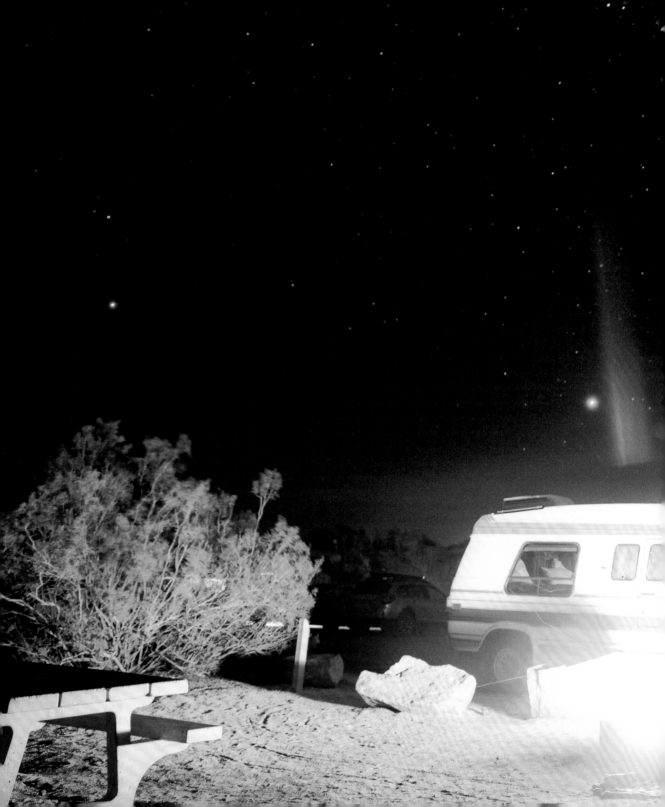

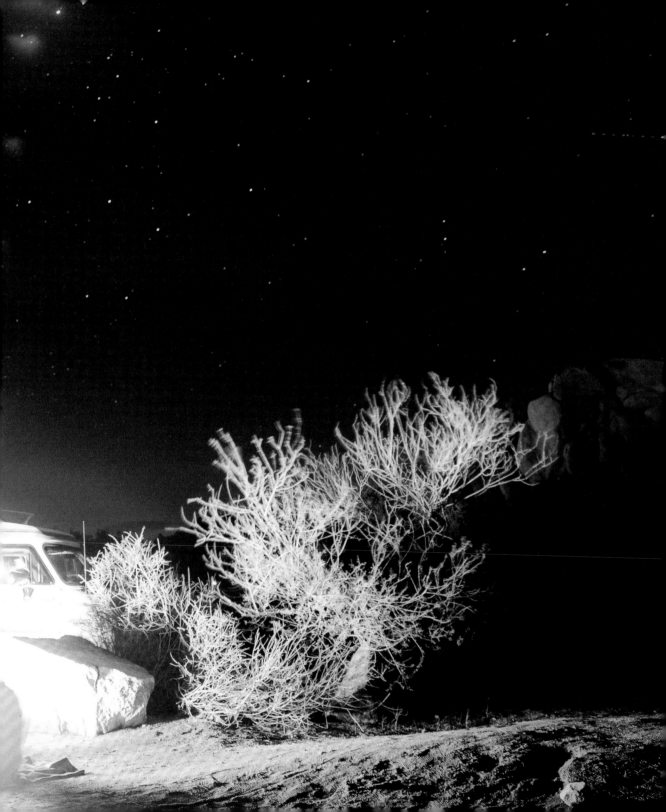

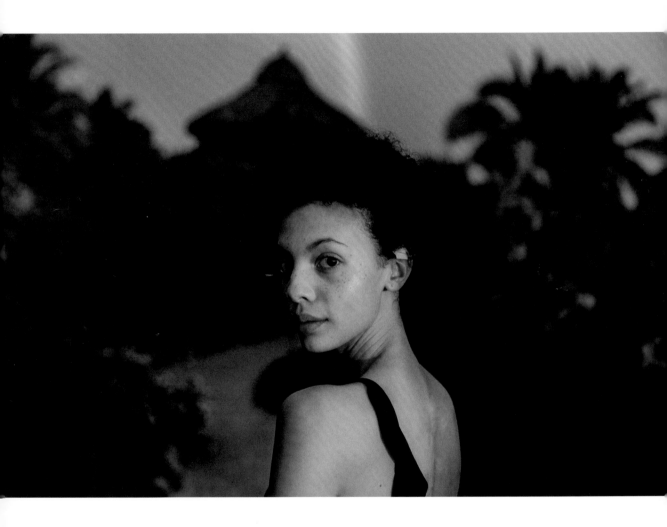

MEXICO
GORDONNAY GAINES NOVEMBER—2018

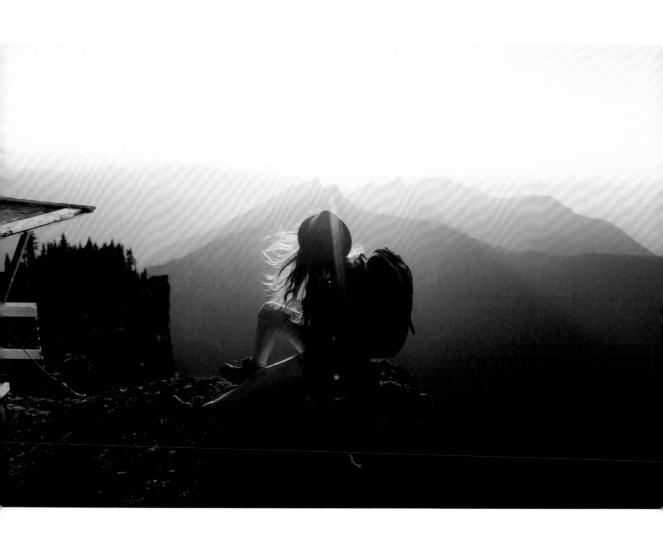

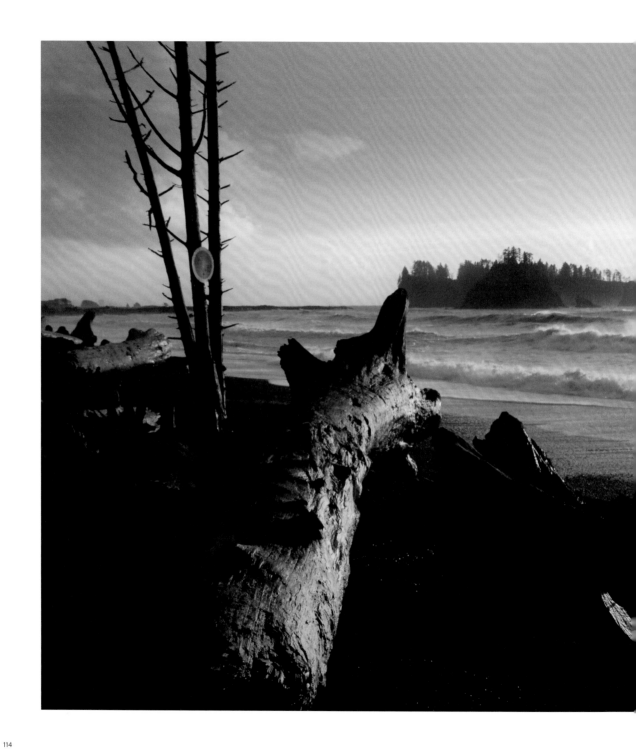

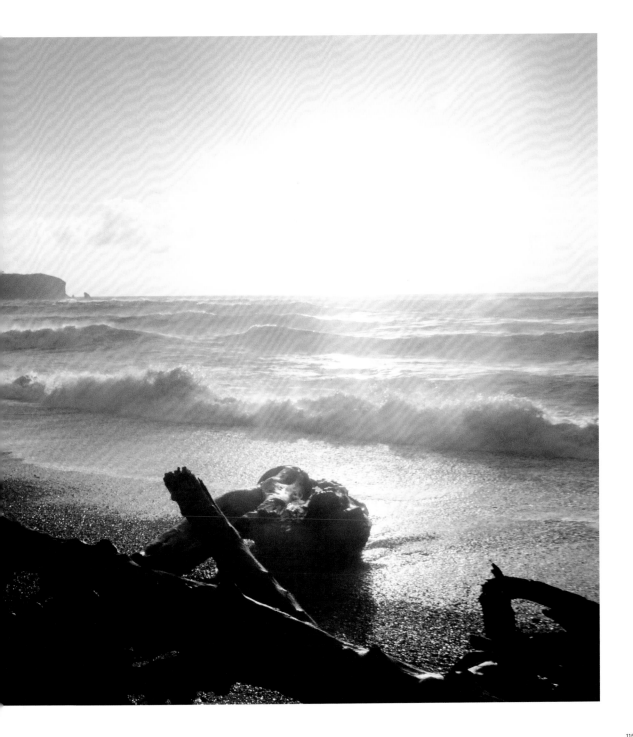

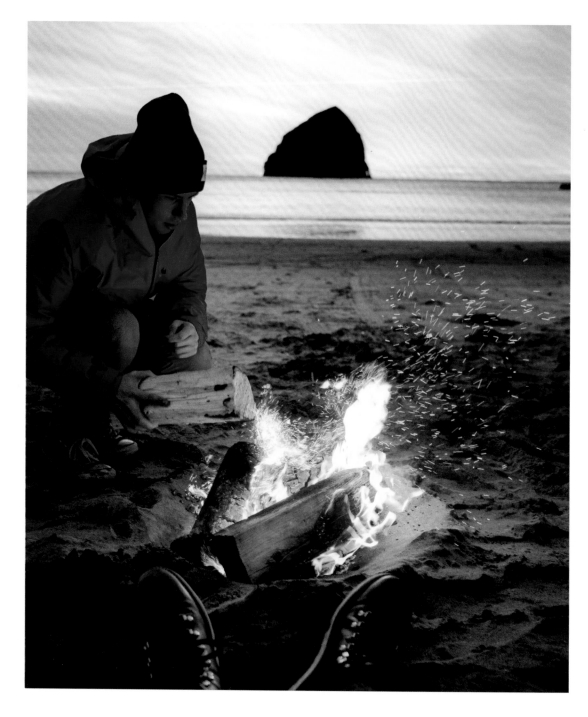

OREGON
MICHAEL FLUGSTAD MARCH—2017

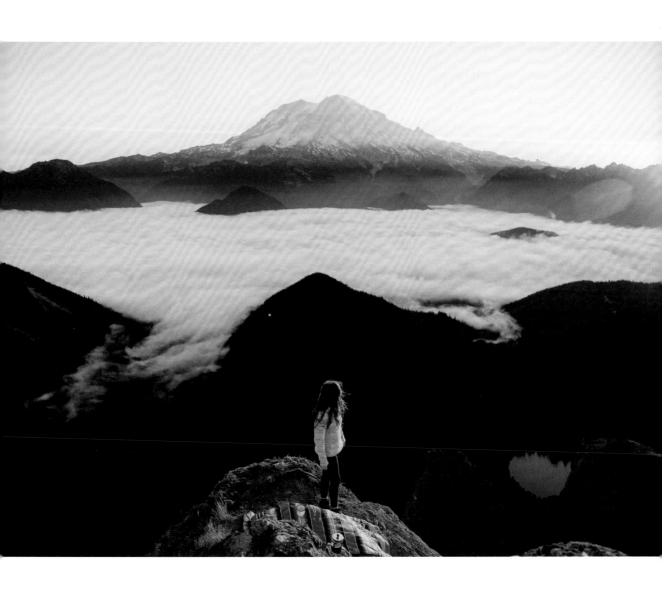

WASHINGTON
BAYLEY JUNES AUGUST—2018

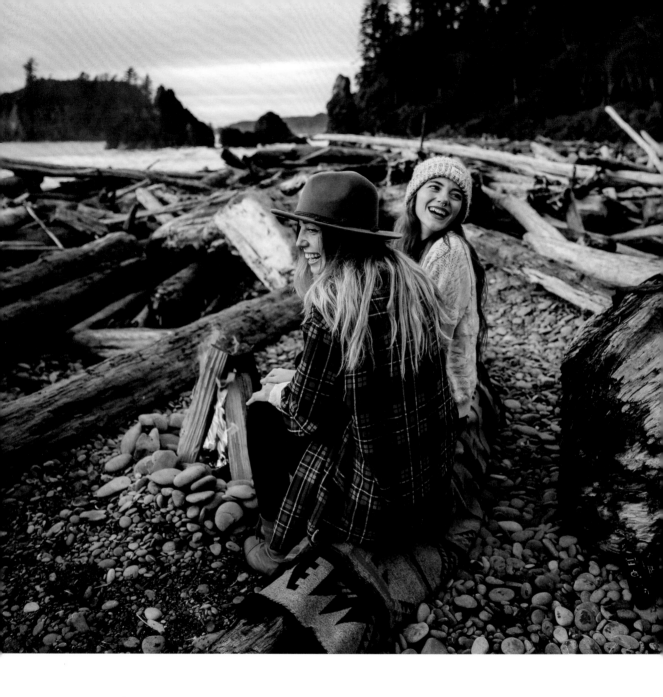

WASHINGTON
RAIMEE MILLER / CHELSEA NOVEMBER—2016

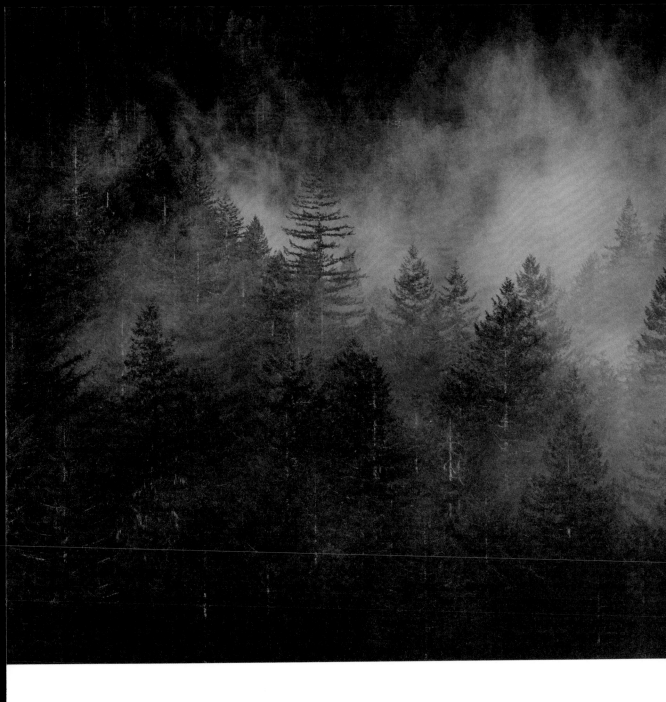

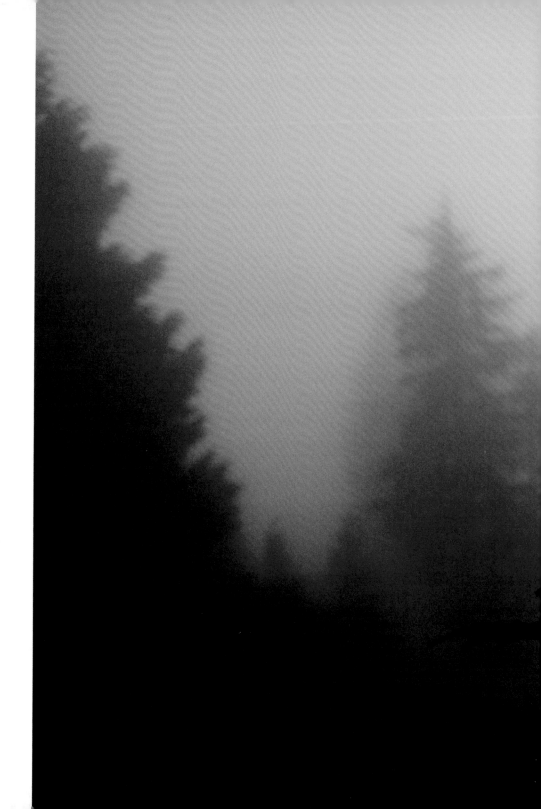

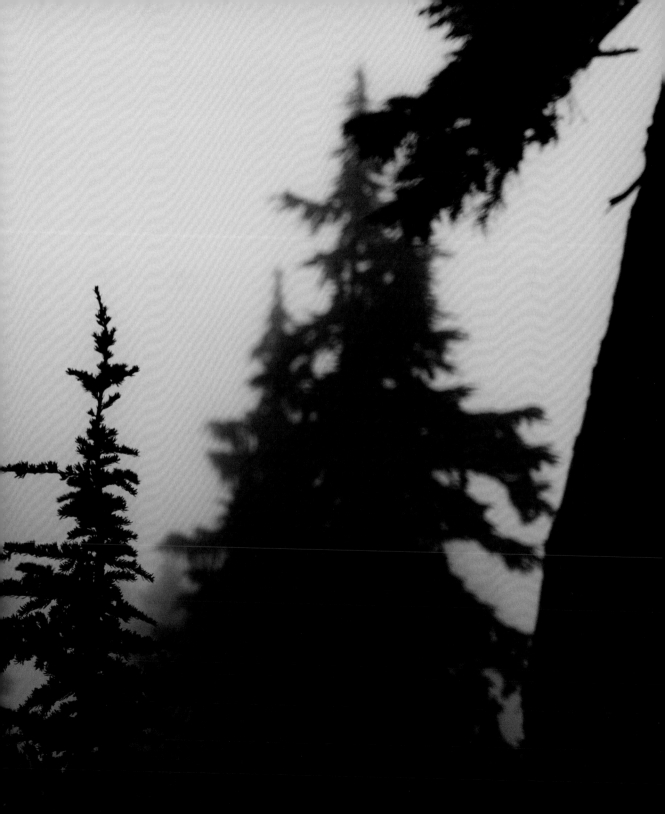

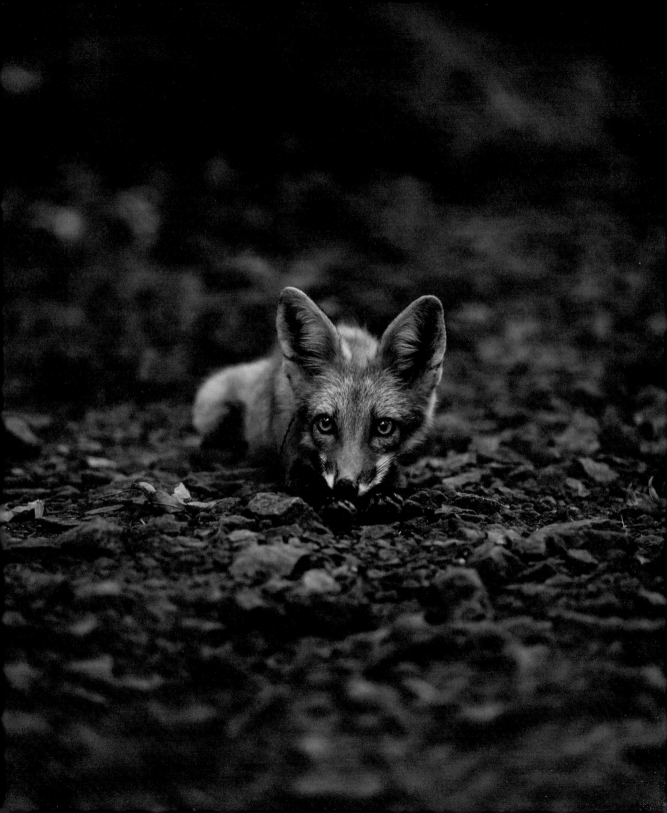

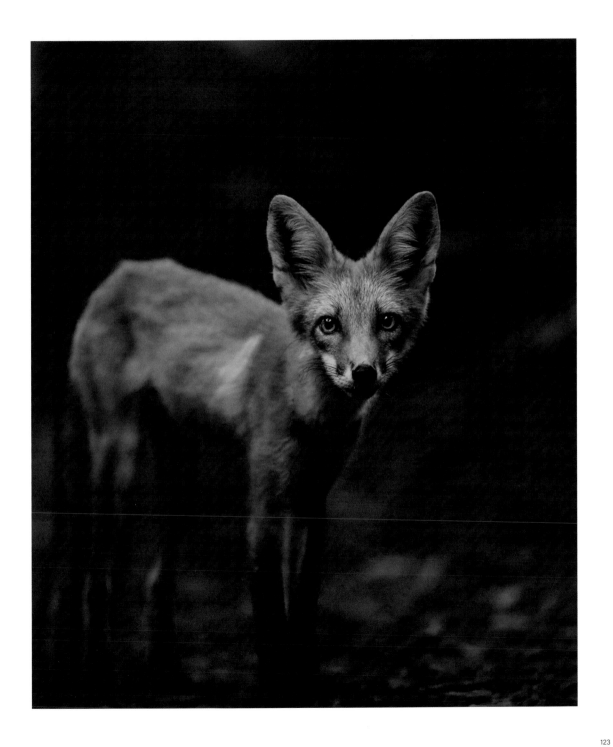

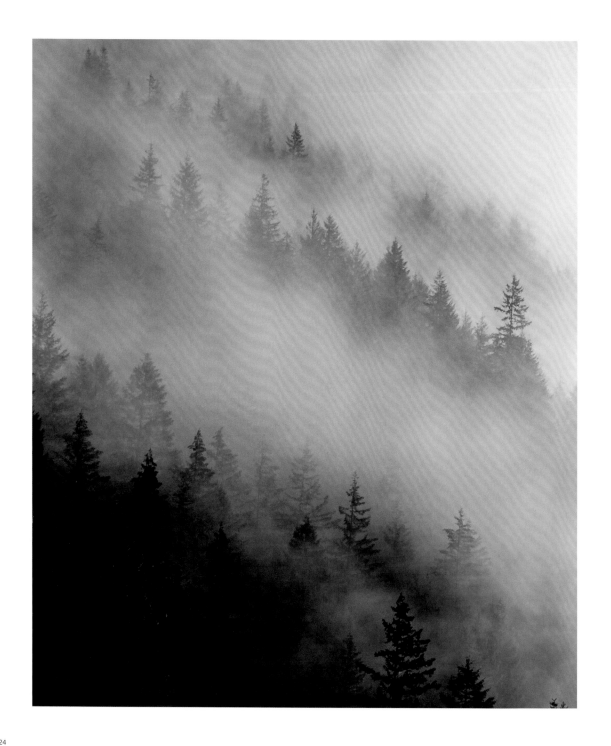

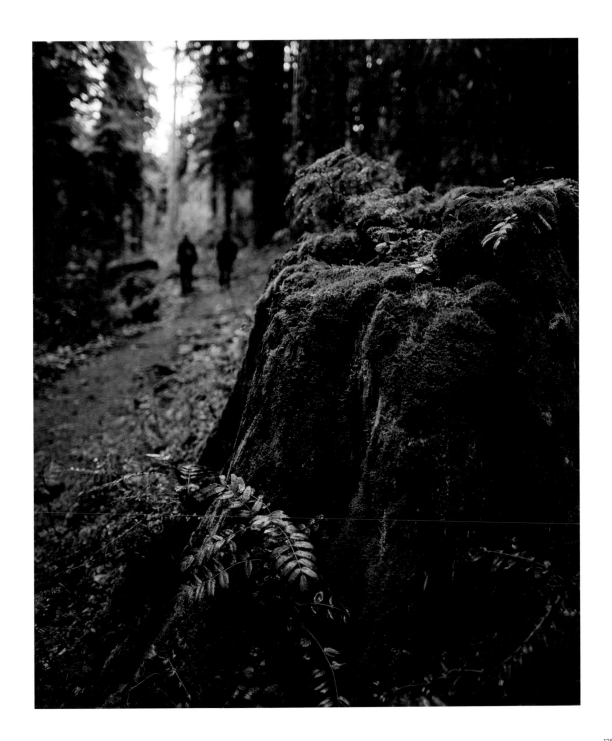

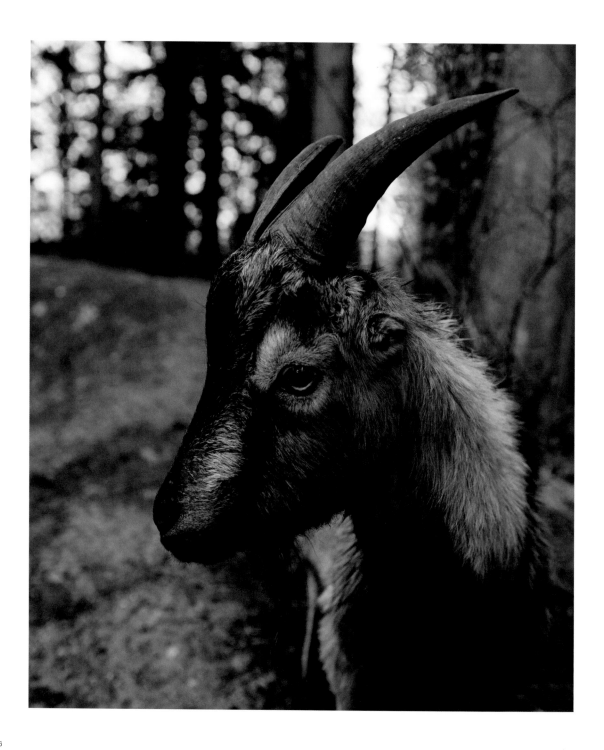

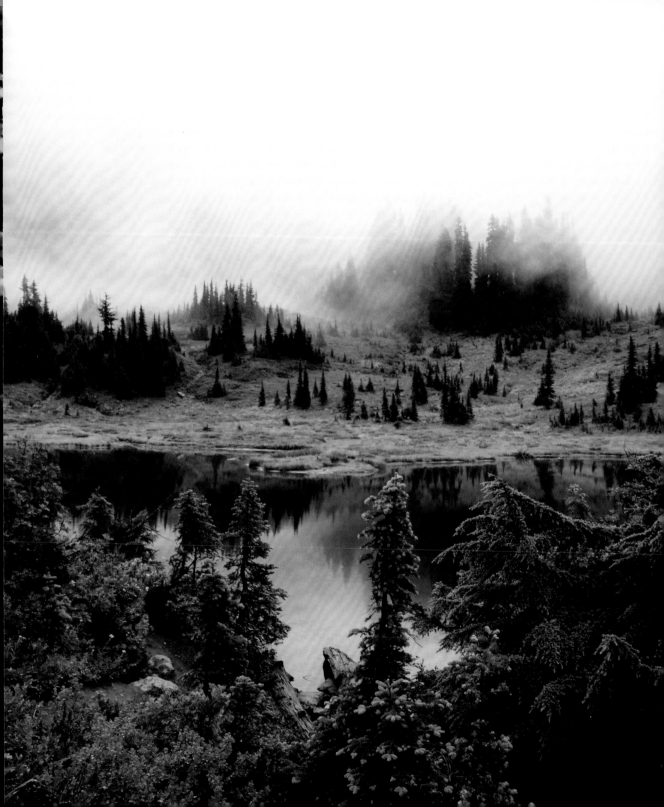

SEPTEMBER 6TH, 2019

I think my job as an artist is to understand and articulate emotions and experiences. Beyond beauty and superficial pleasures, this is what human souls need and crave. The only way to really, truly connect is to be open and vulnerable. It's a painful process, and often it's hard to let these things go into the world. To lose ownership over them.

Ultimately it's a beautiful thing. We have the ability to change people's lives for the better, to shift their understandings and interactions. It comes down to living with intent. These relationships, stories, connections… they're what make life beautiful and vibrant. Alive.

This is why I create.

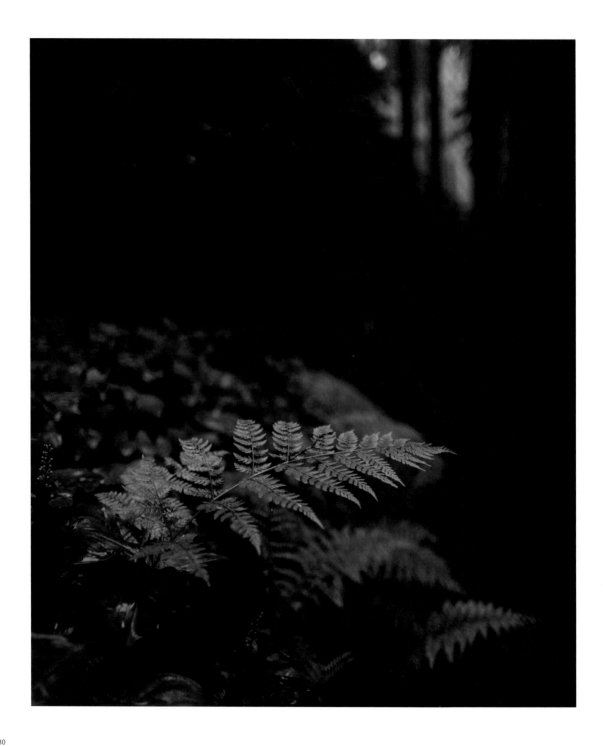

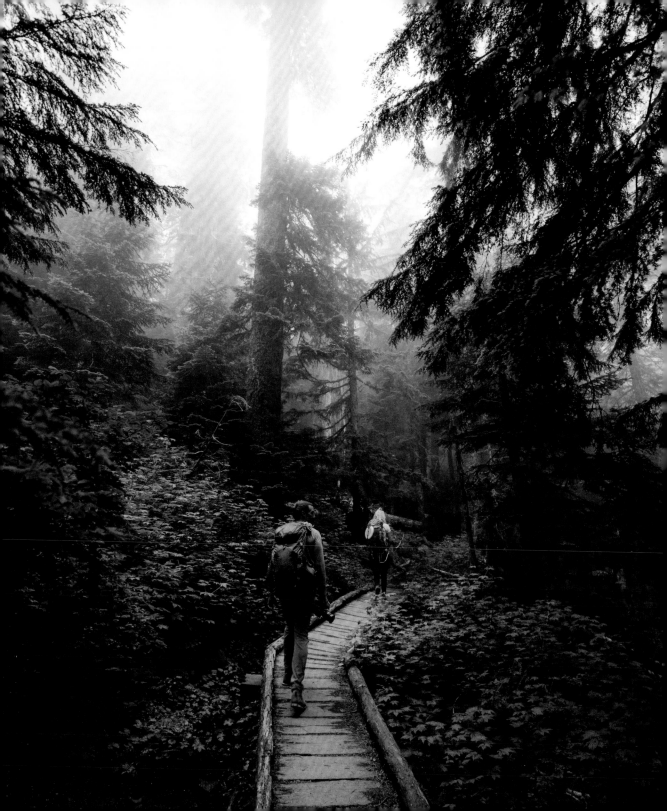

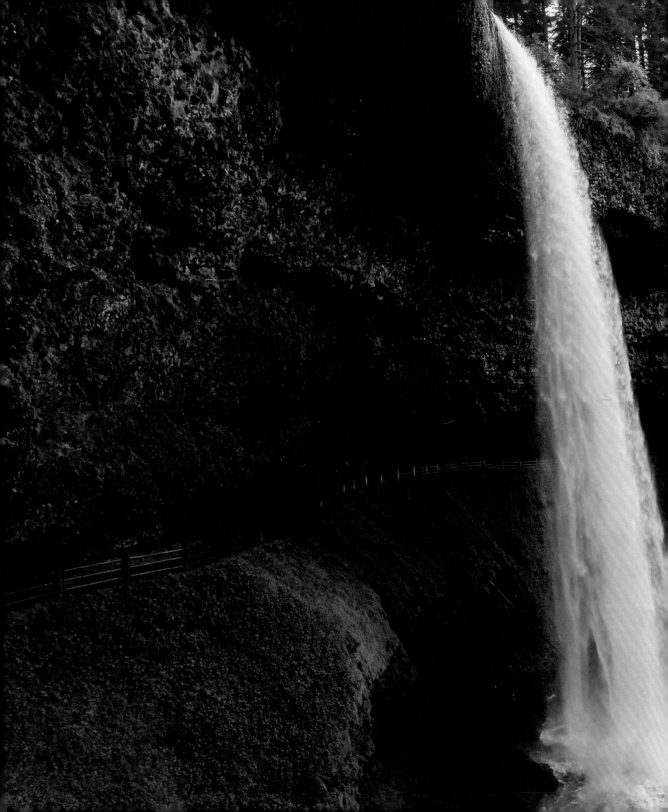

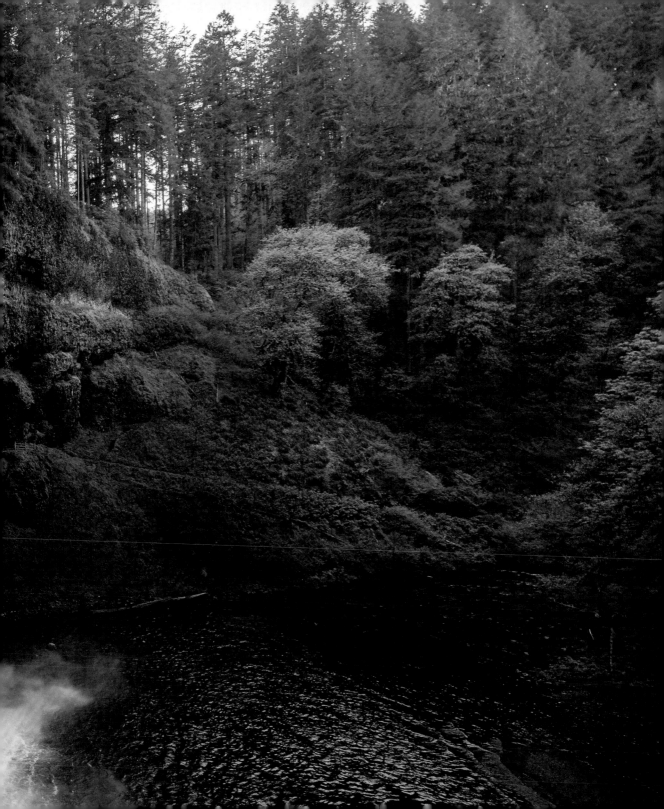

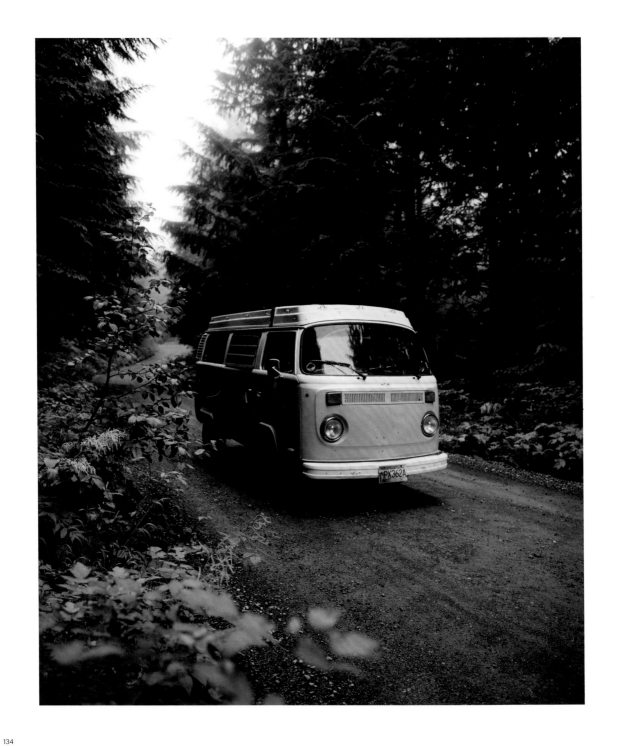

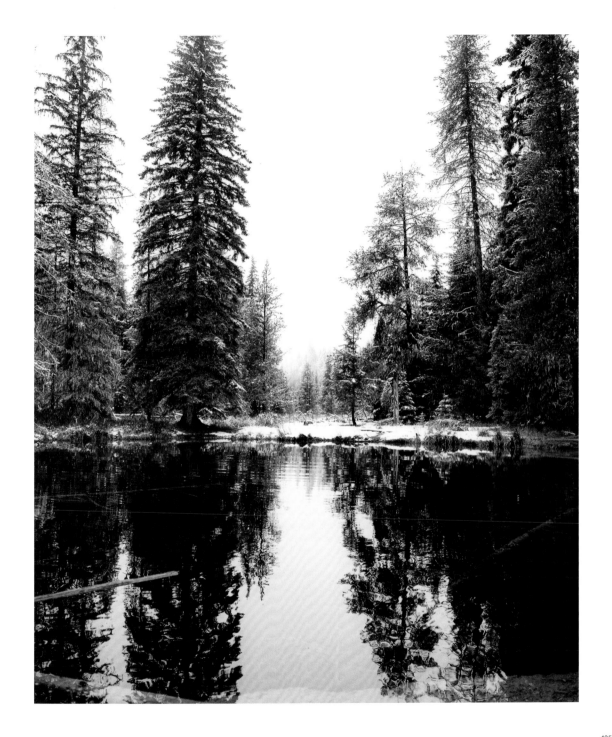

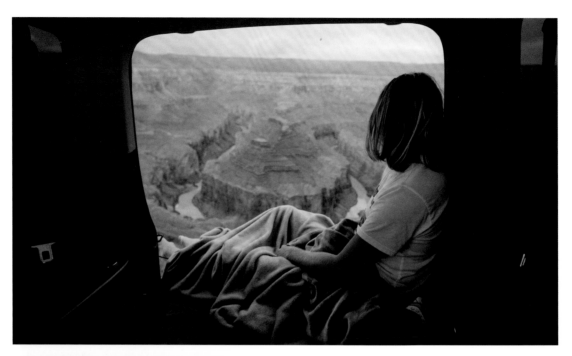

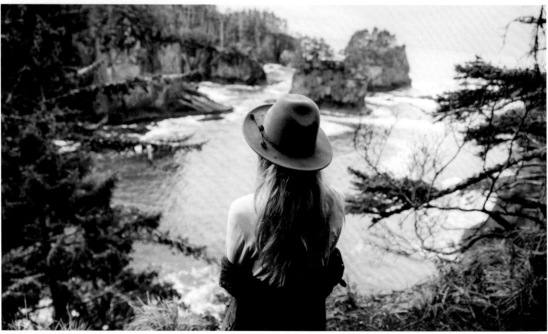

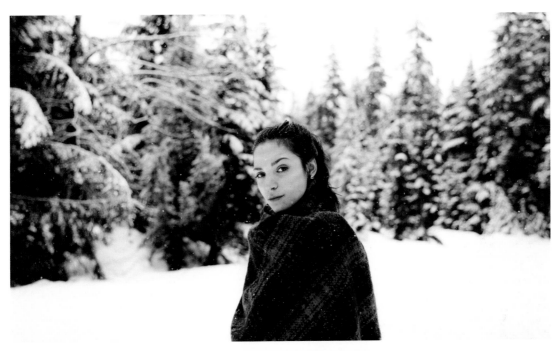

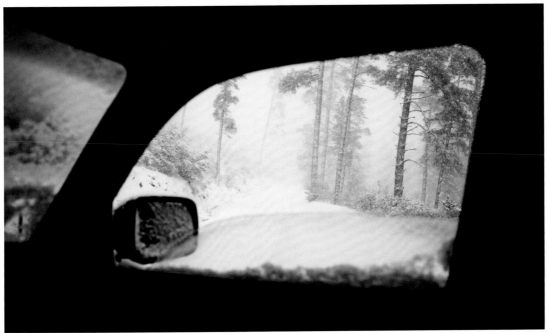

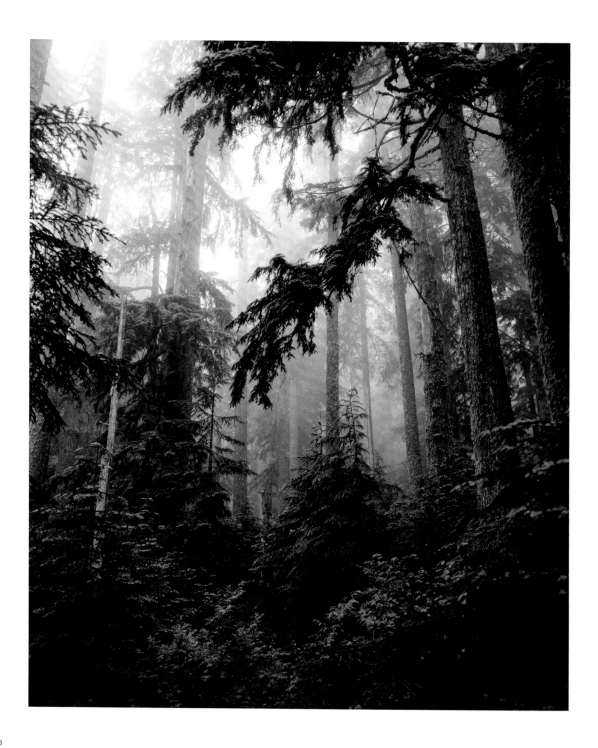

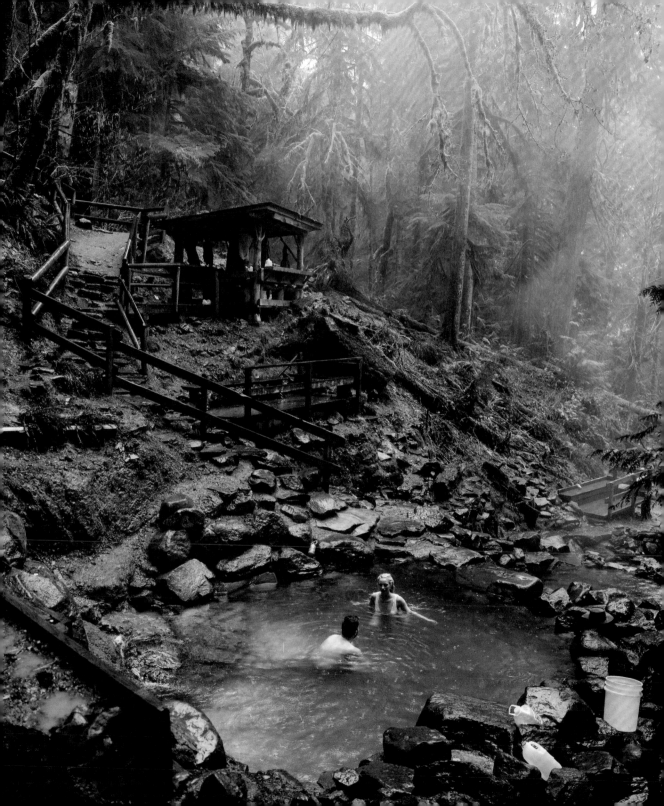

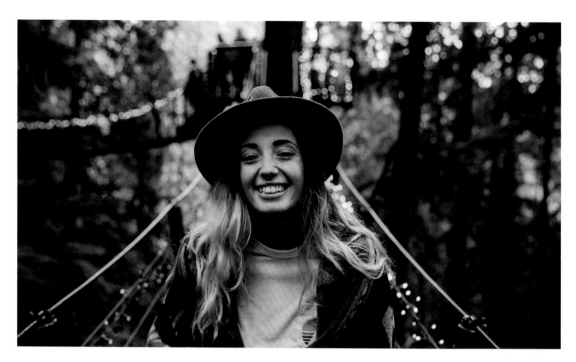

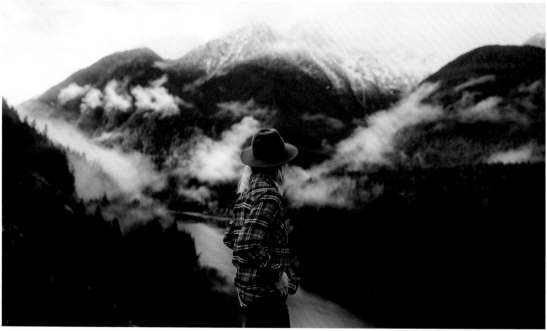

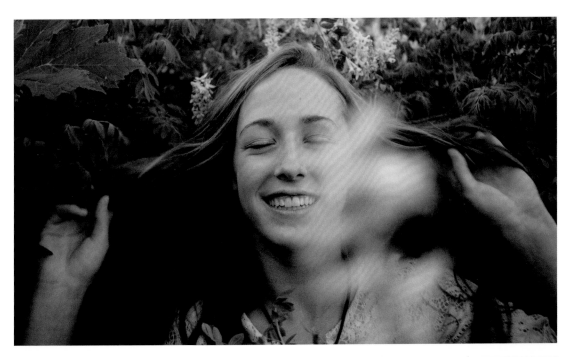

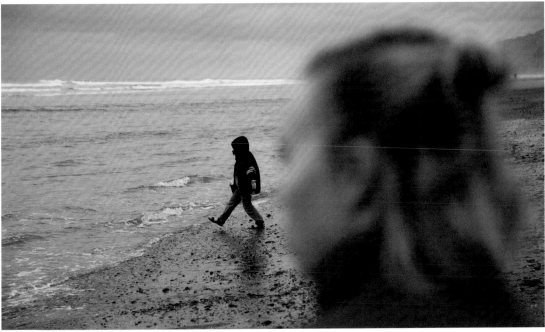

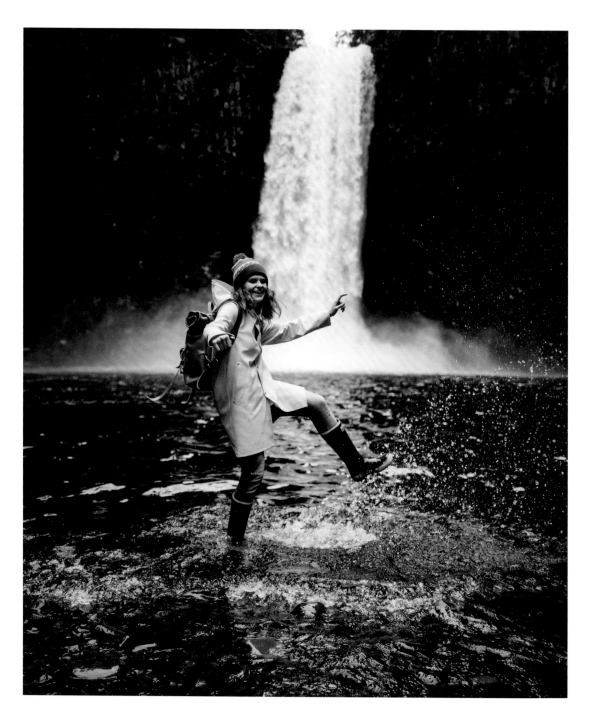

OREGON
EMILY EVANS MAY—2017

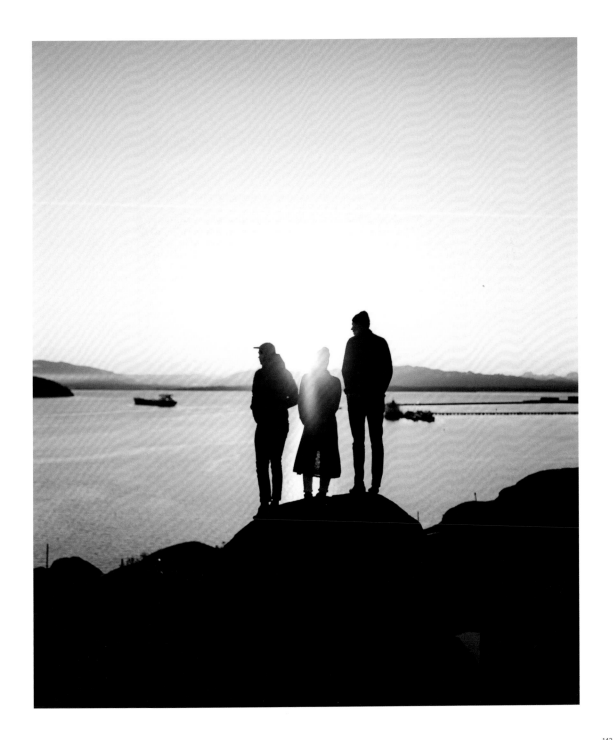

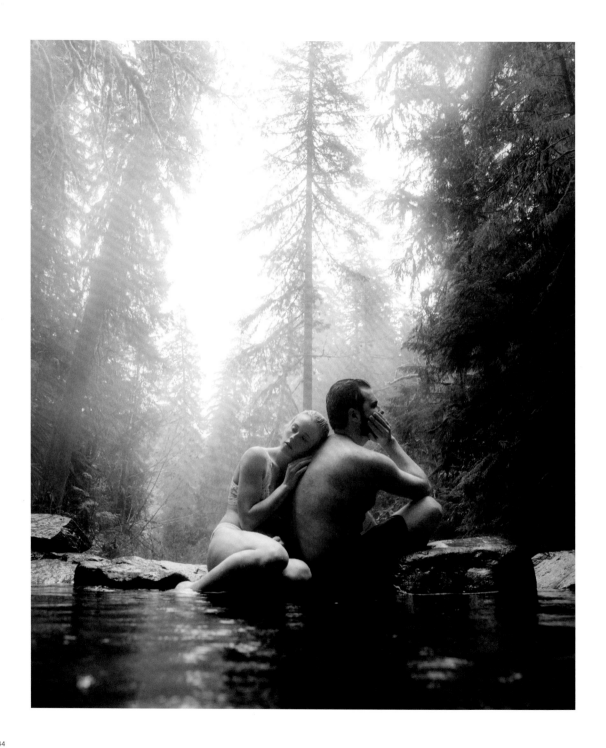

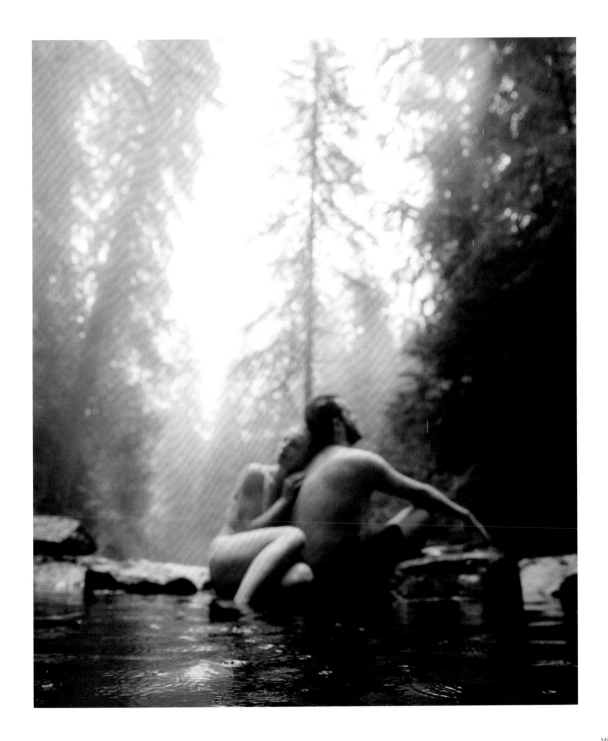

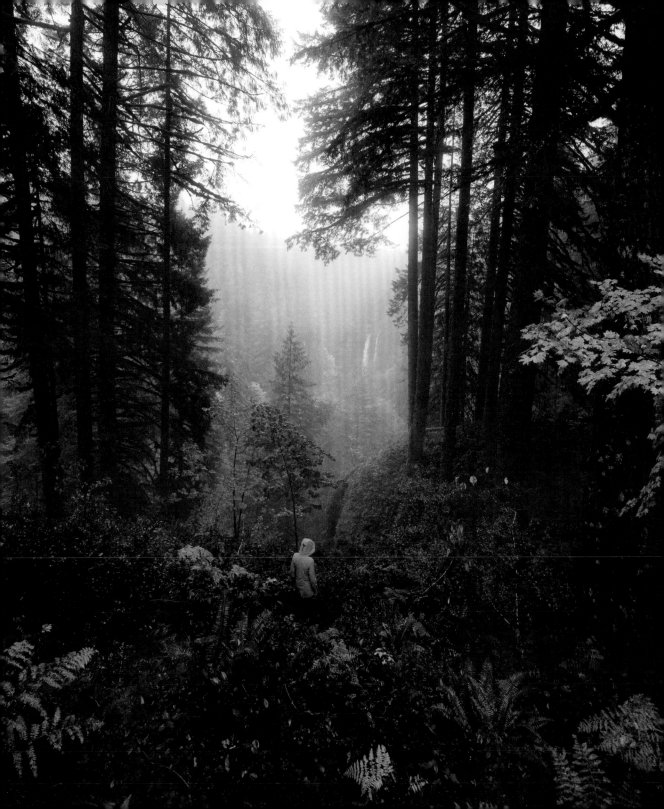

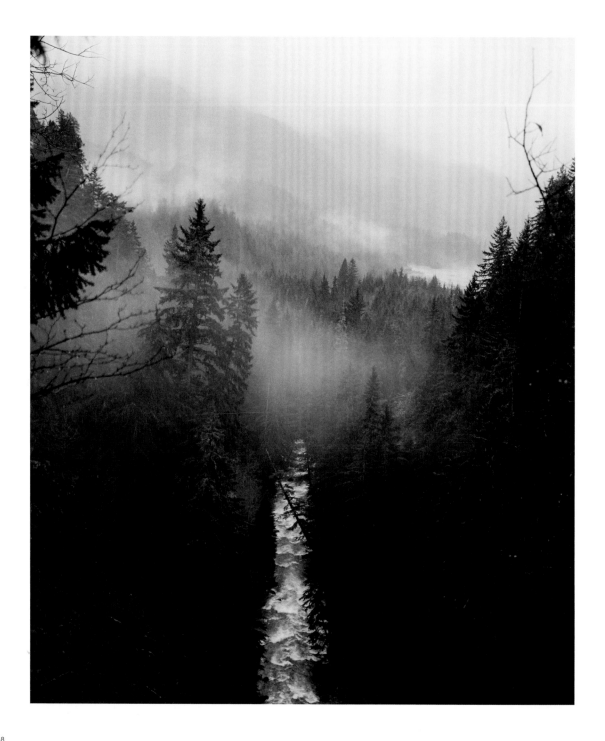

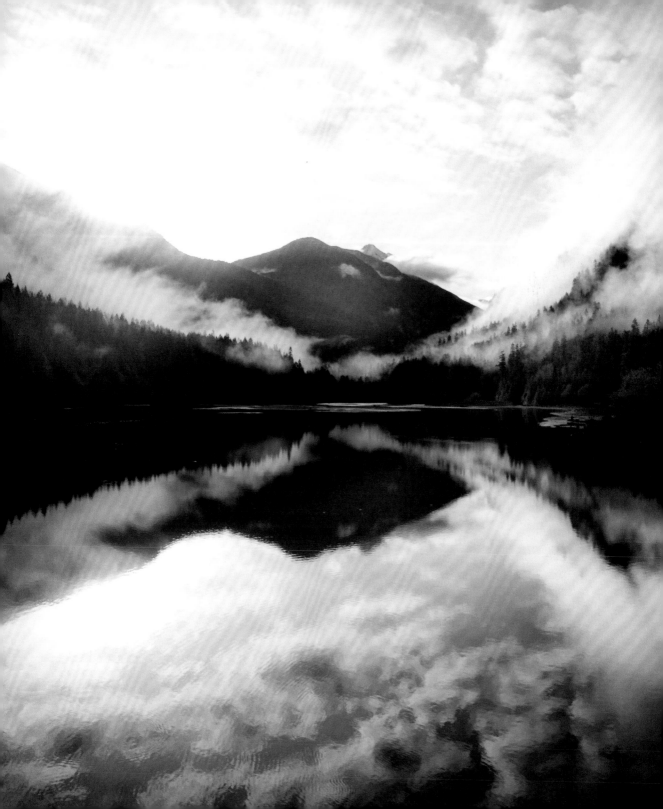

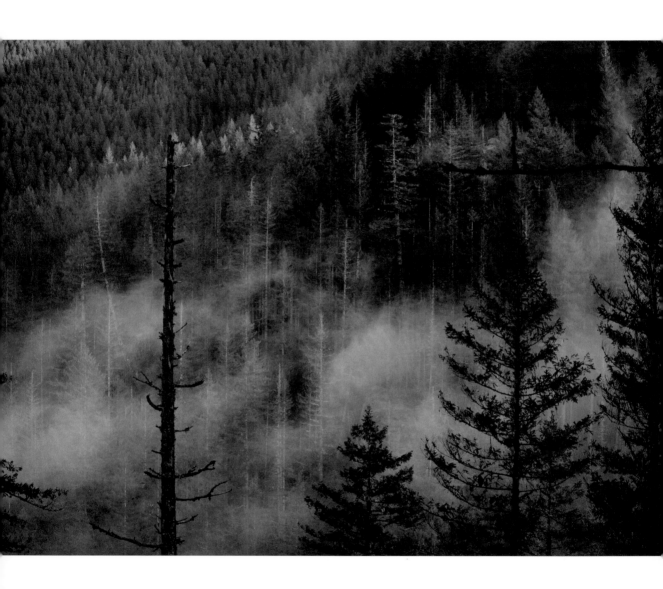

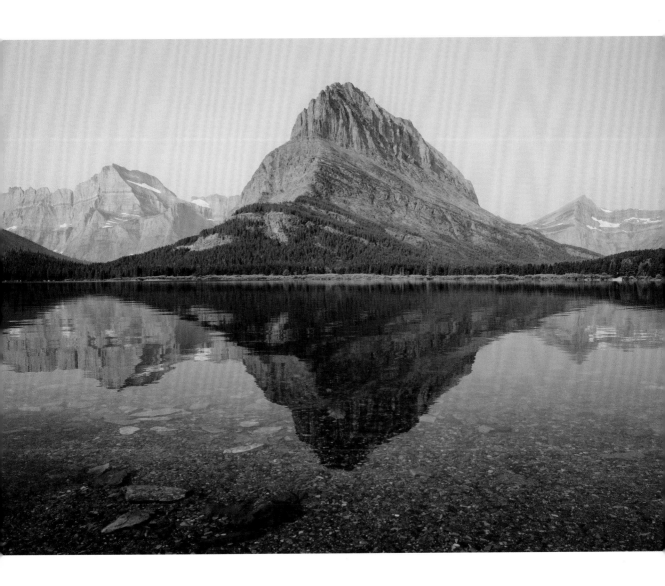

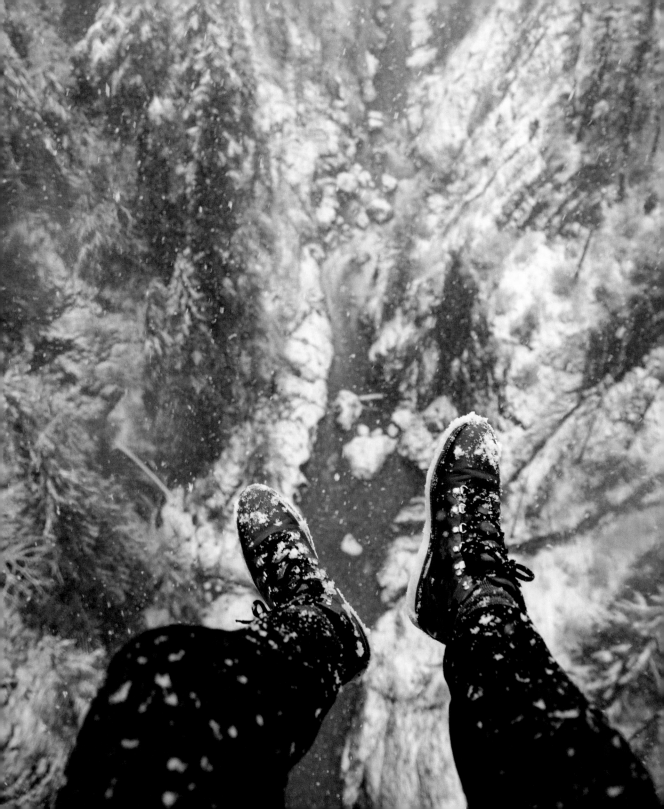

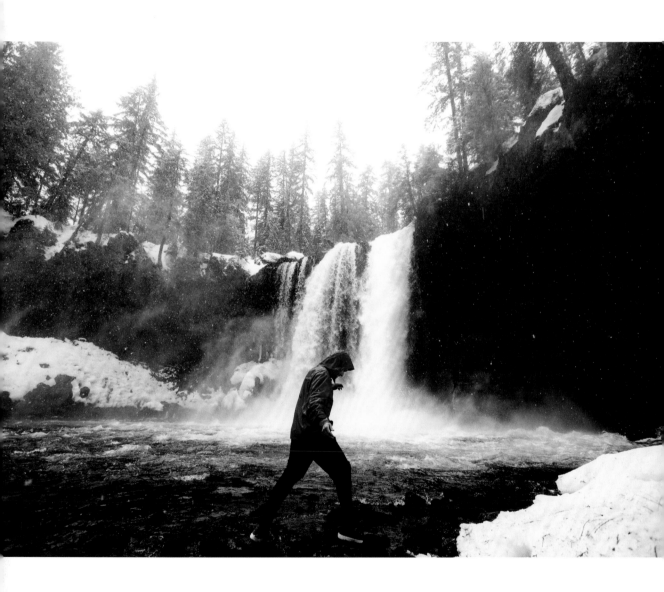

PERÚ

Life-changing experiences don't happen often. When they do, they're usually impossible to explain to others.

My father has always been drawn to the mountains. After he graduated high school in Long Beach, California, he quickly found himself living in a teepee high in the Sierra Nevada for two years. Later, he met my mother in the small Colorado ski town they would come to raise me in. During the first years of their love, they would take yearly trips to Nepal to trek with the little money they had earned running a chimney sweep business.

I was born to the mountains, raised for the mountains, taught to admire and respect the mountains. I would say this was my father's gift to me. It's also what brought us to Perú. A father with a dream and son he wanted to share it with.

The dream was of the Cordillera Blanca, a stretch of peaks reaching over 20,000 feet in altitude, sporting glacial caps, an impassable terrain, a rugged culture and people, wildness, and uncertainty.

This project holds a special place in my heart. Twenty-one days of travel and twenty rolls of film. Finding the space to breathe freely amongst some of Earth's thinnest air.

Experiencing mountains such as these, it's hard not to leave without a sense of humility and appreciation for this incredible world we all share.

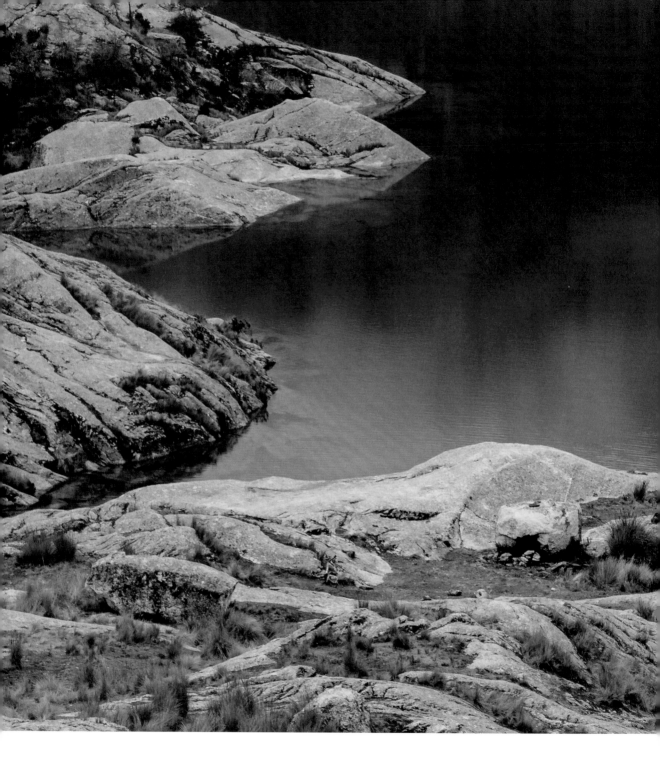

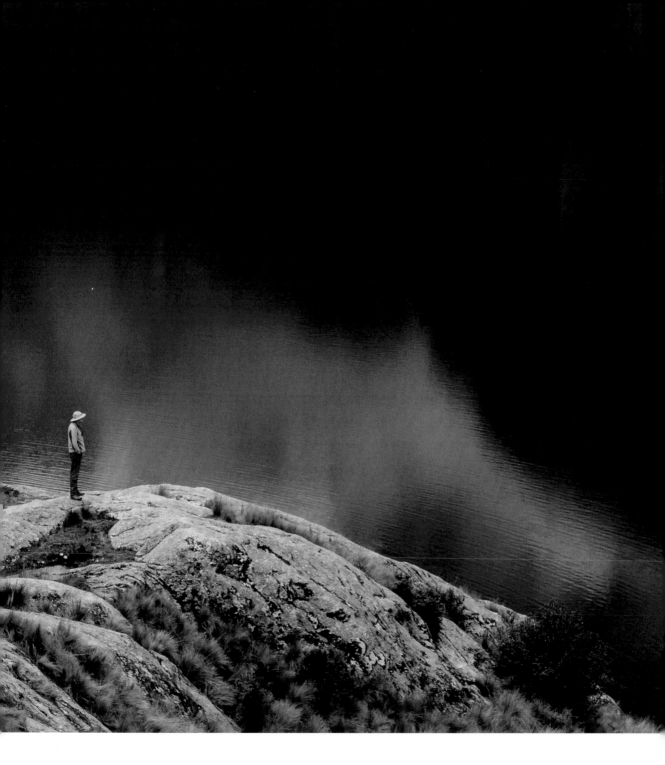

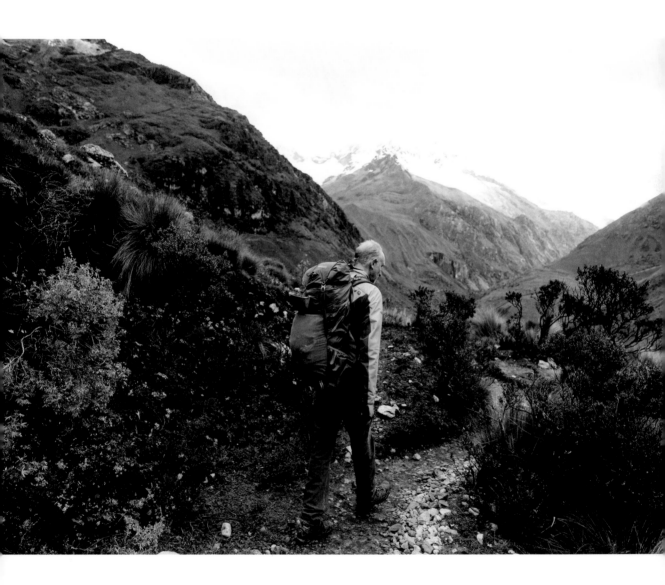

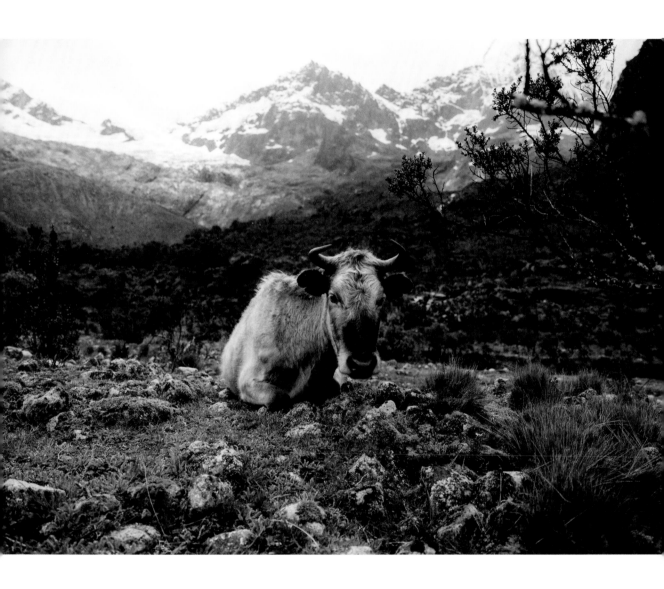

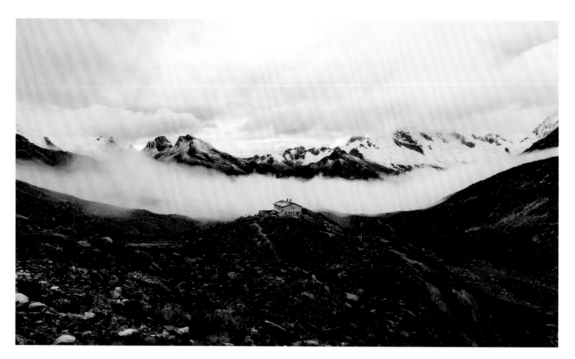

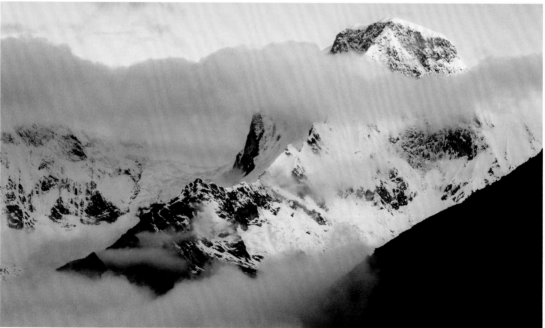

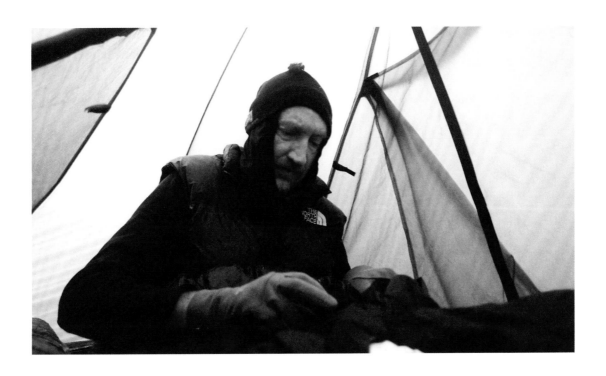

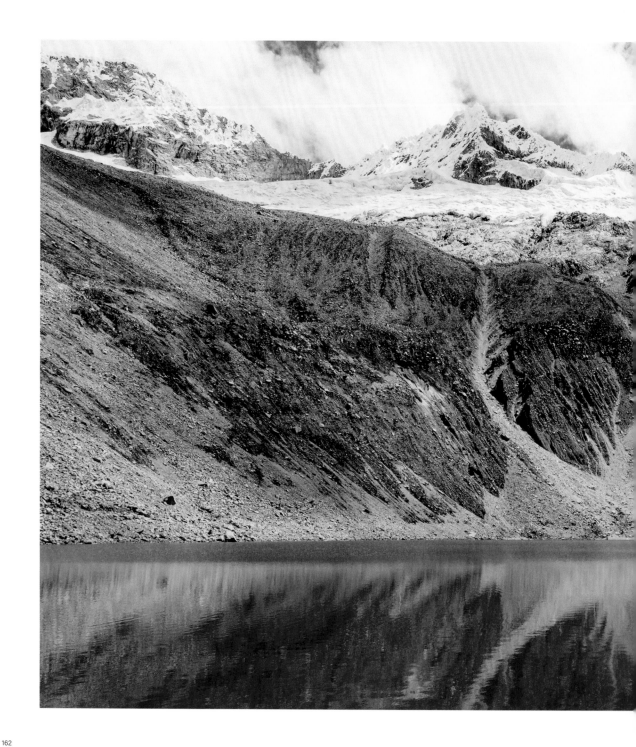

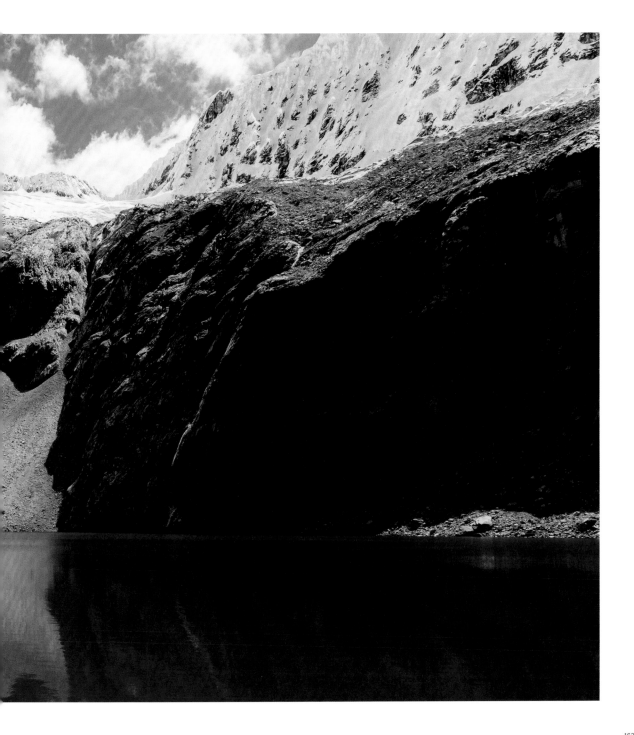

I think every dream grows from somewhere. I'm constantly forgetting where I planted mine. My idea of home always seems to change as I reach further out into the world, grasping for potential, opportunity, exposure. Somewhere a long time ago I planted a seed. I hoped one day it would grow into an adventurous life filled with love and wonder. I still remember looking up towards the skies as a child, trying to count stars as the Earth turned. Where does this wonder go? At what point do we stop looking up to think of the possibilities or just to feel at home in the expansiveness of it all?

These feelings don't stop when you grow old, but I do in fact feel that we hide them from sight. Ideas of success, failure, milestones, and markers blur the dreams we once held dear. In my mind, the only successful people are the ones who grow old with their dreams and wonder—the ones who hold onto their curiosities and spirits. There's a purity that life will rob you of if you let it. Broken dreams and hearts, unfulfilled promises, hurts and aches. Don't lose what was gifted. This life is a blessing and you are a blessing to it. Your heart was made to last no matter what blows it may endure.

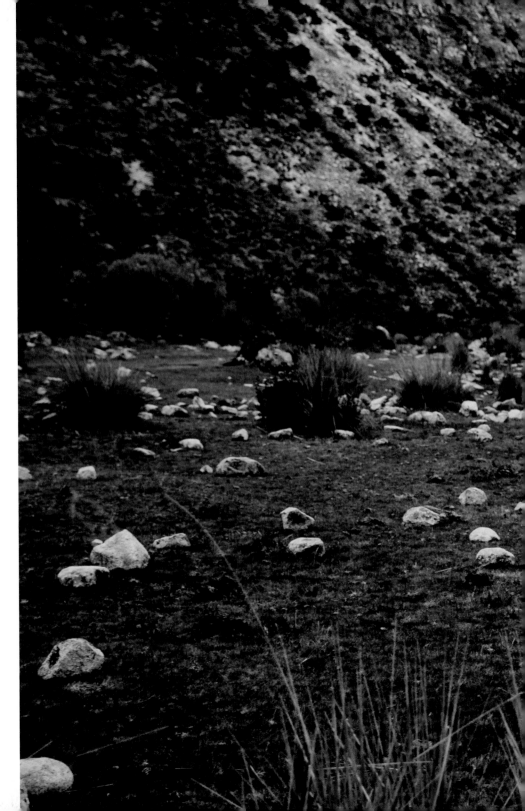

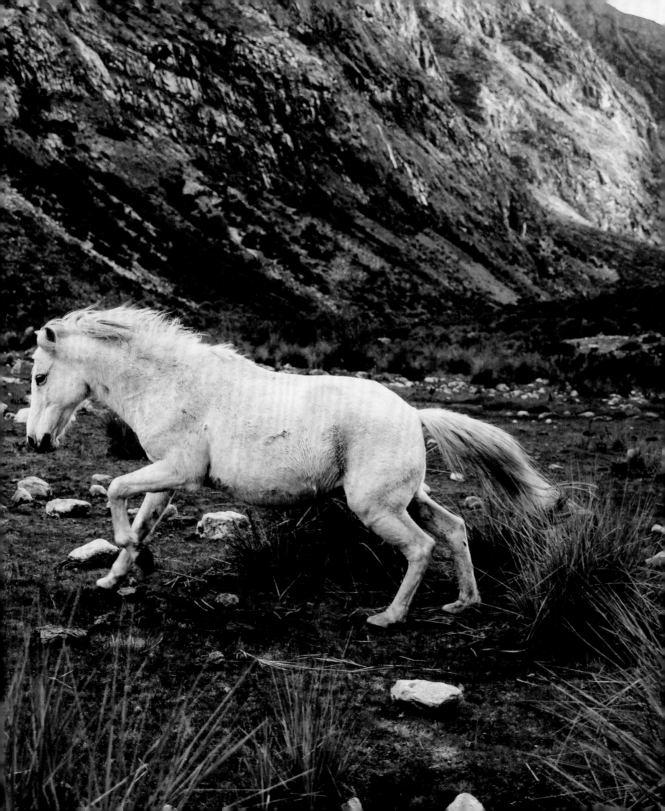

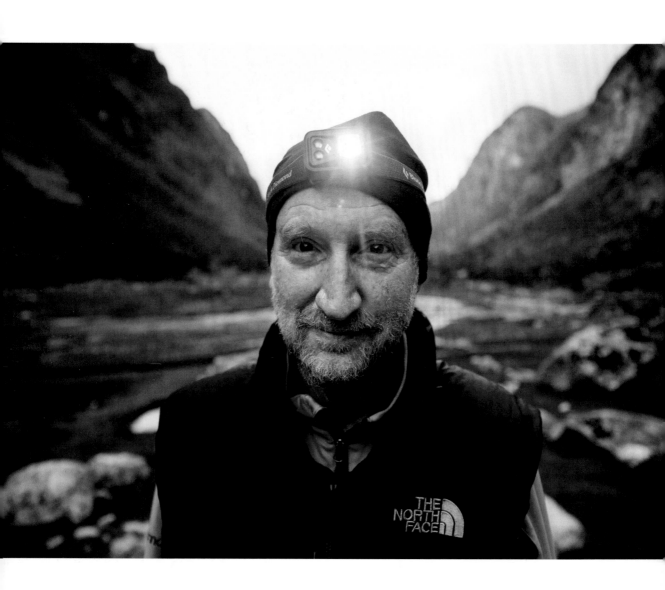

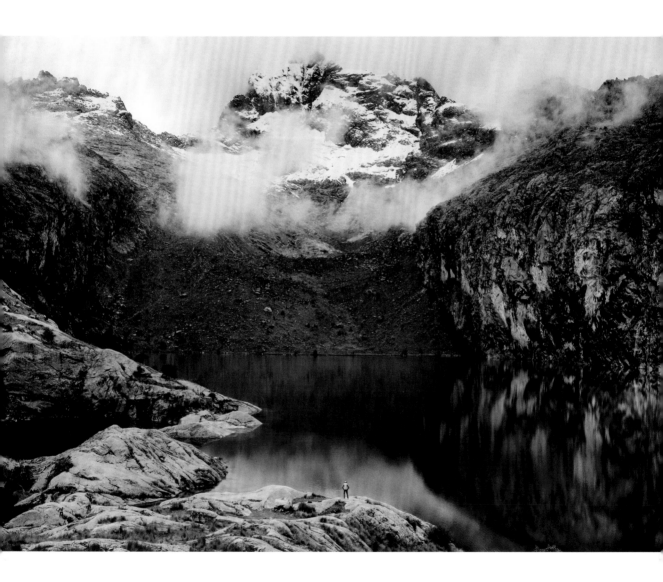

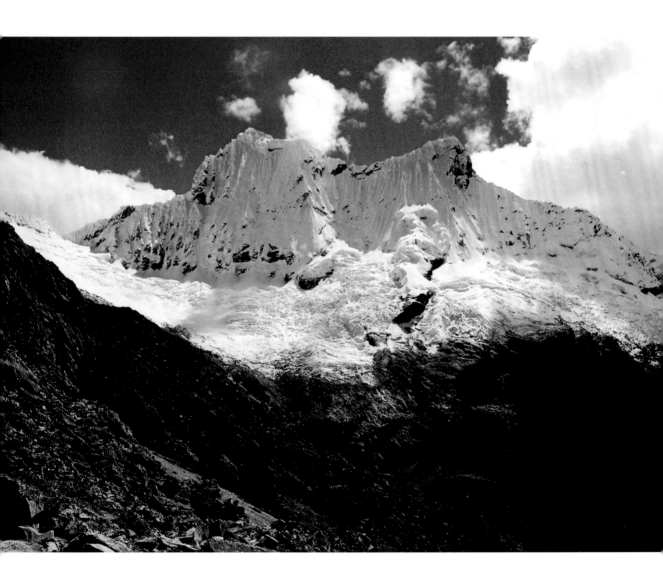

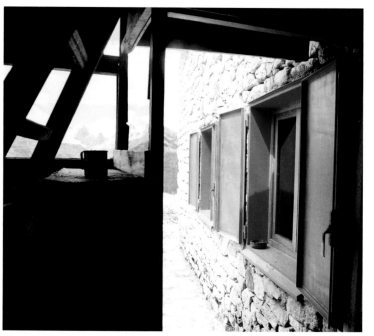

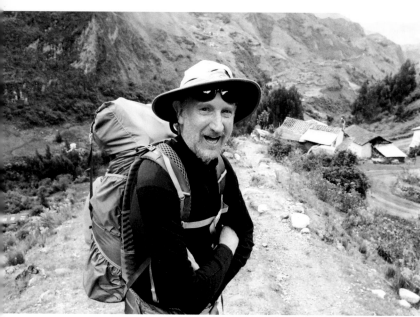

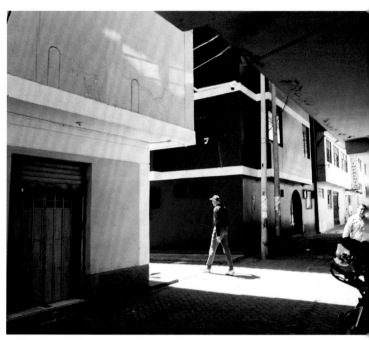

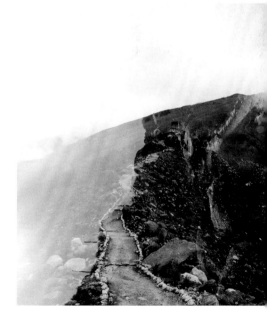

ALASKA

All my life I've dreamt of places like these. Mountains larger than your imagination could fathom, glaciers that slowly carved them into the shapes they are today. The scale in which these landscapes are built is unparalleled, a real frontier. In the modern age, these spaces have become few and far between. Truly untouched wilderness is a rarity.

What brought me to Alaska was the idea of wildness—the feeling of being in places few have been before. With only a few roads connecting the state as a whole, it isn't uncommon to find yourself completely engulfed in nature—surrounded by mountain peaks reaching to the sky over fields of ice that slowly shift the land below. Often I've found my experience in places like this to be a surrender of sorts. The potential of catastrophe is always present as you walk through wildness. A change in weather or an unexpected encounter could mean death, but the risk of visiting these spaces is amply rewarded. To experience the wild, you have to become a little wild yourself.

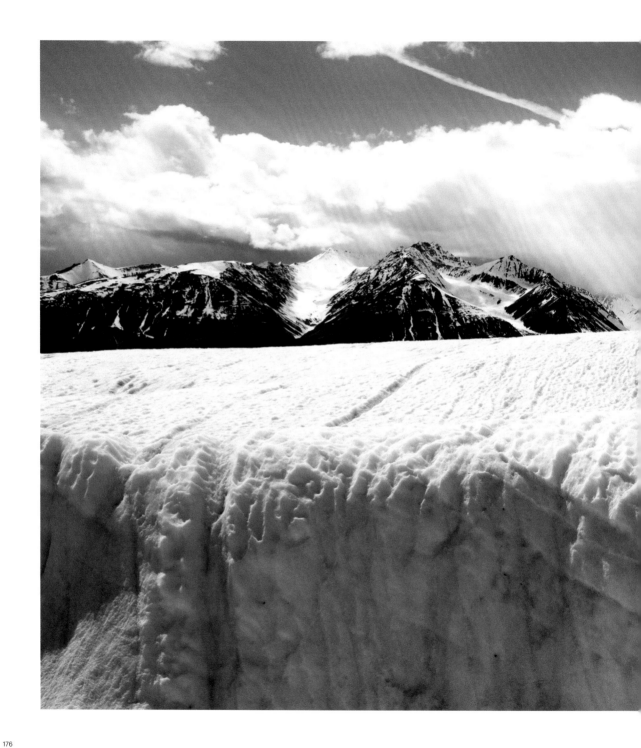

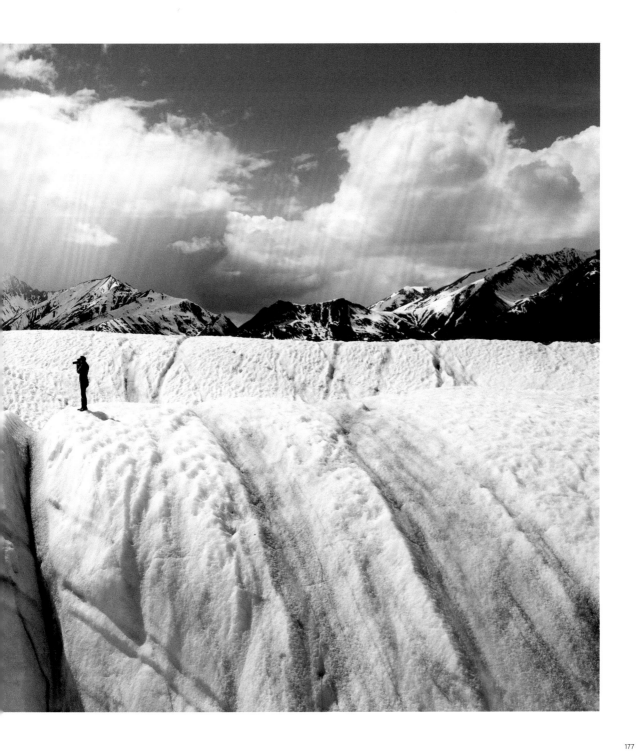

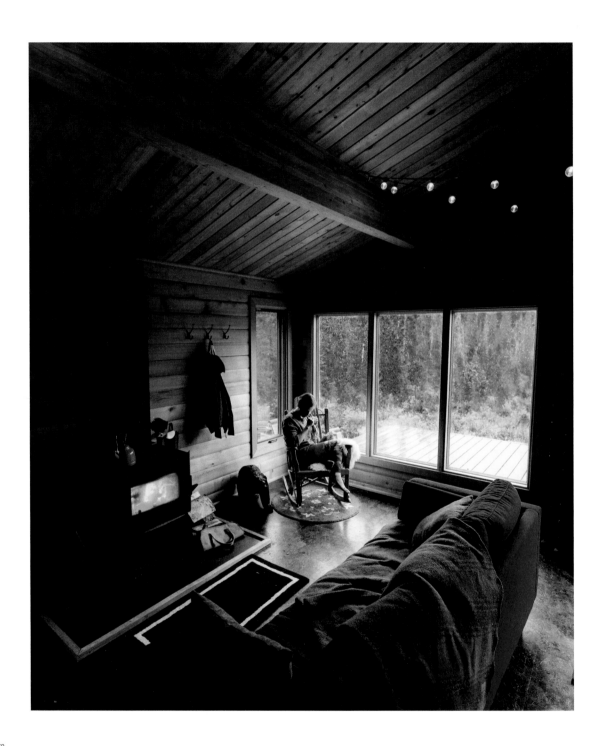

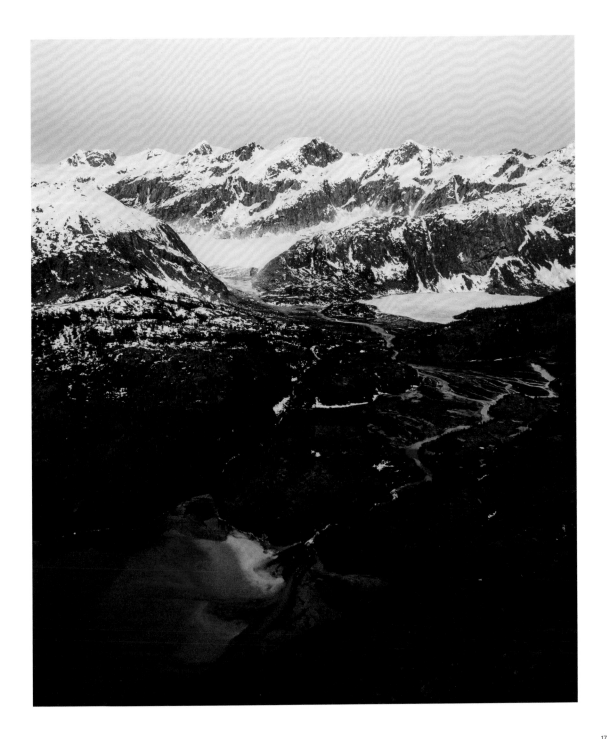

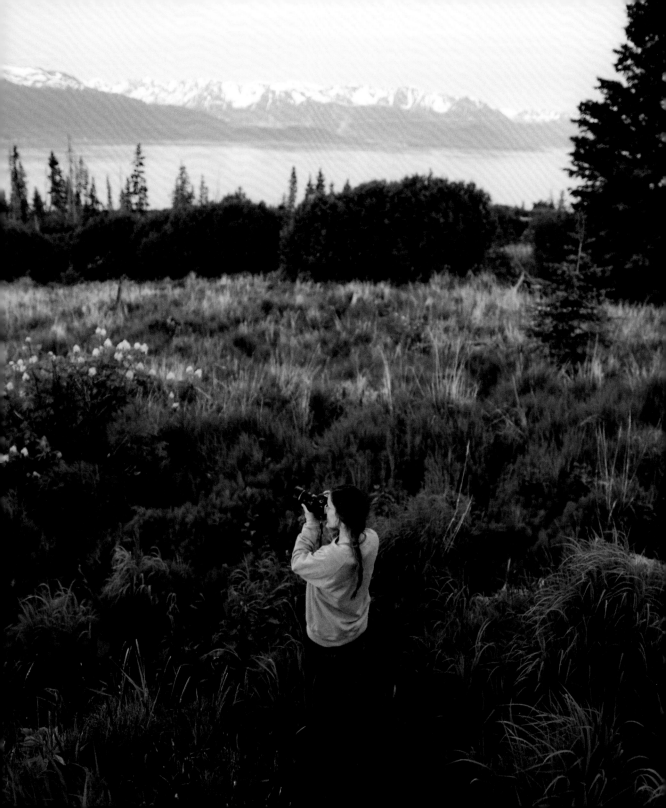

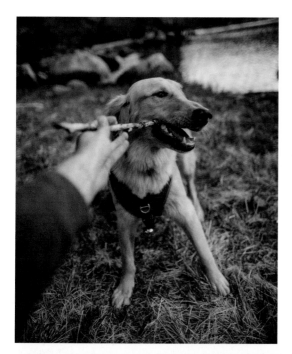

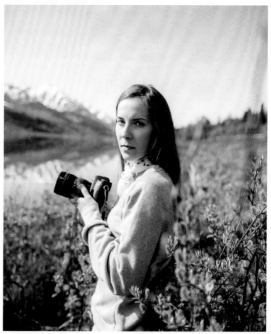

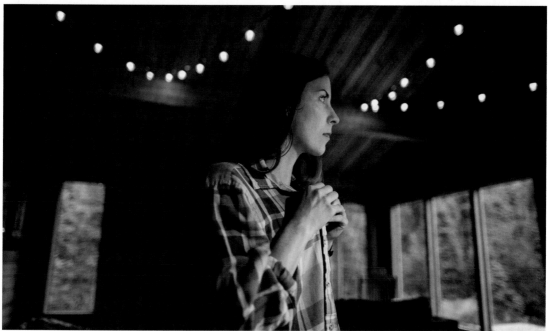

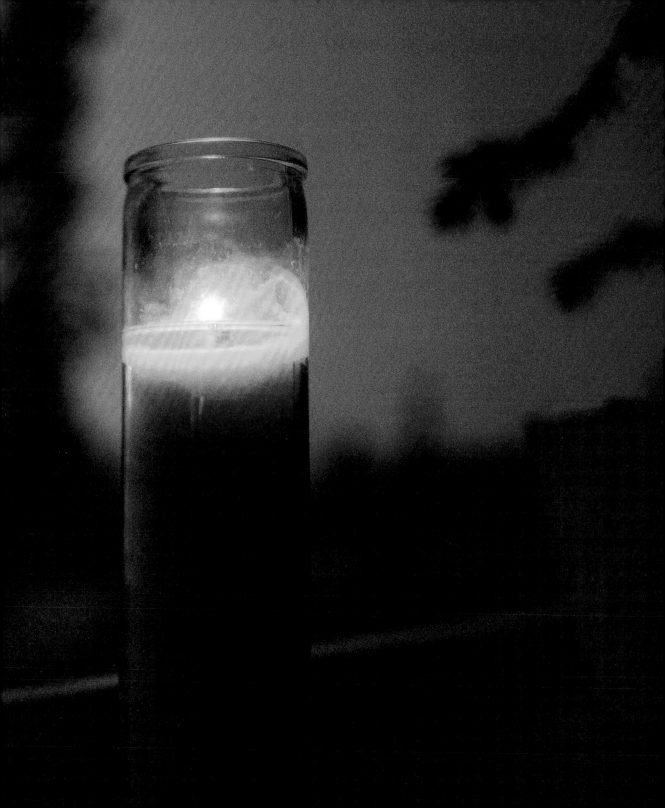

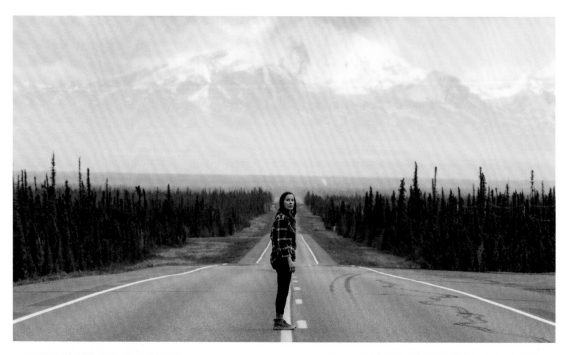

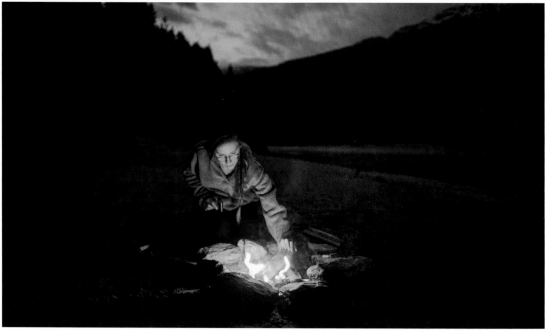

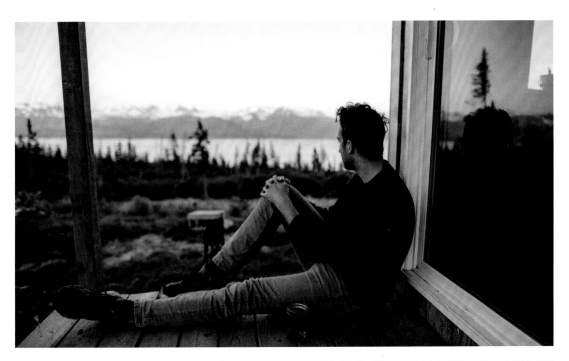

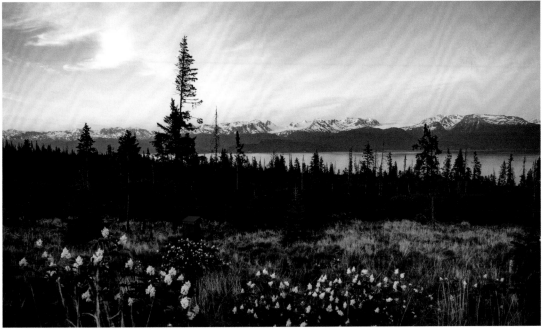

YOUNG. NAIVE. INSPIRED.

For three years, summer sun lit our way towards an unpredictable future. As we squeezed our youth from dusty back roads and star-filled nights, we found something we could never have predicted. Thin spaces, a sort of spirituality we practiced amongst mountain peaks, the valleys that run through them, and moments of inspiration they gifted us with.

Colorado let us peek beyond the horizons we knew oh so well, the American West came to define our youth. Alaska showed us the expansiveness of the world, Perú let us touch the sky as if there was no limit.

These places brought me to myself. They taught me love, they taught me freedom. They taught me the value of growth and change, they taught me how to find peace in myself.

I think in the end, they taught me to live life just a little *wilder.*

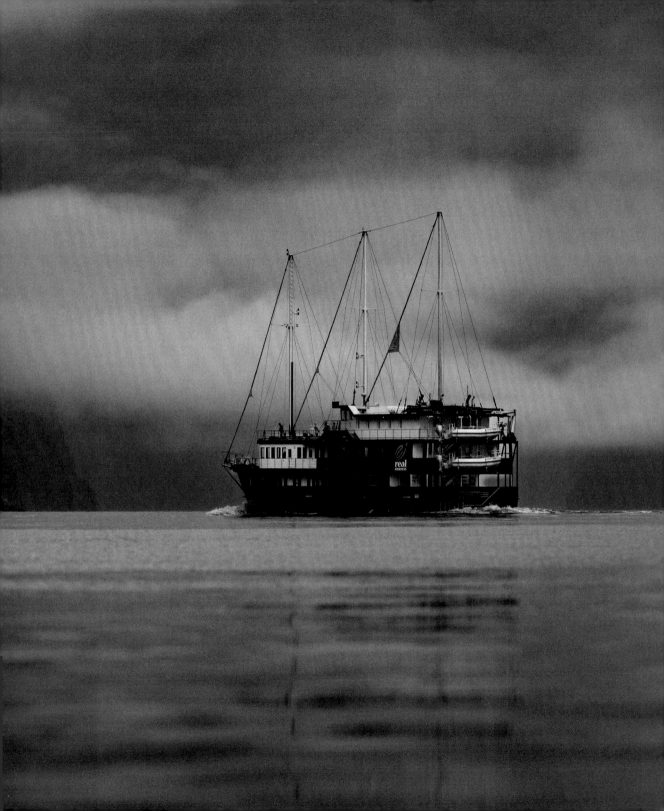

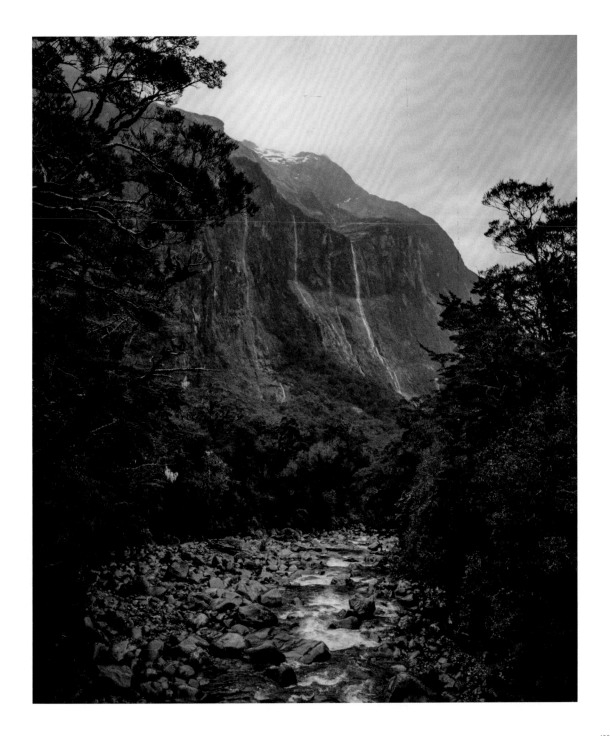

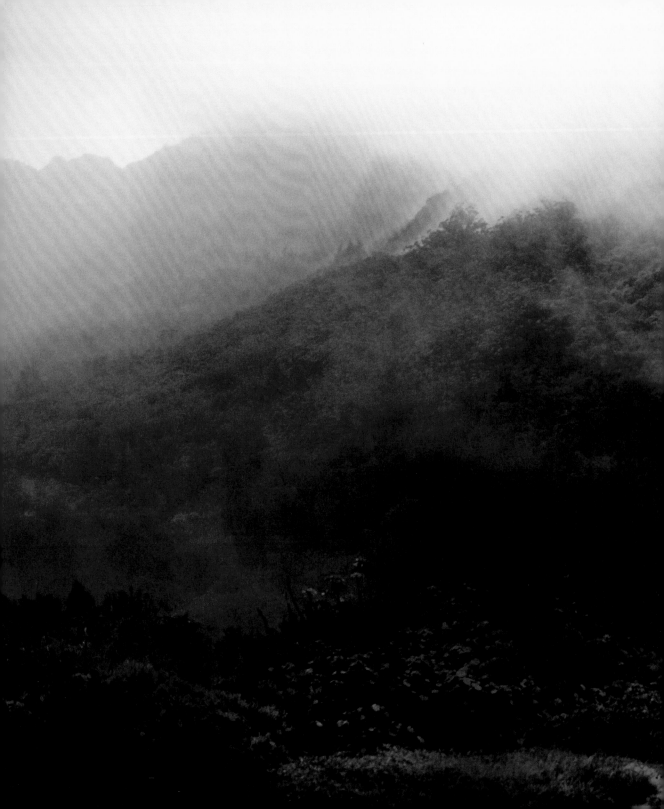

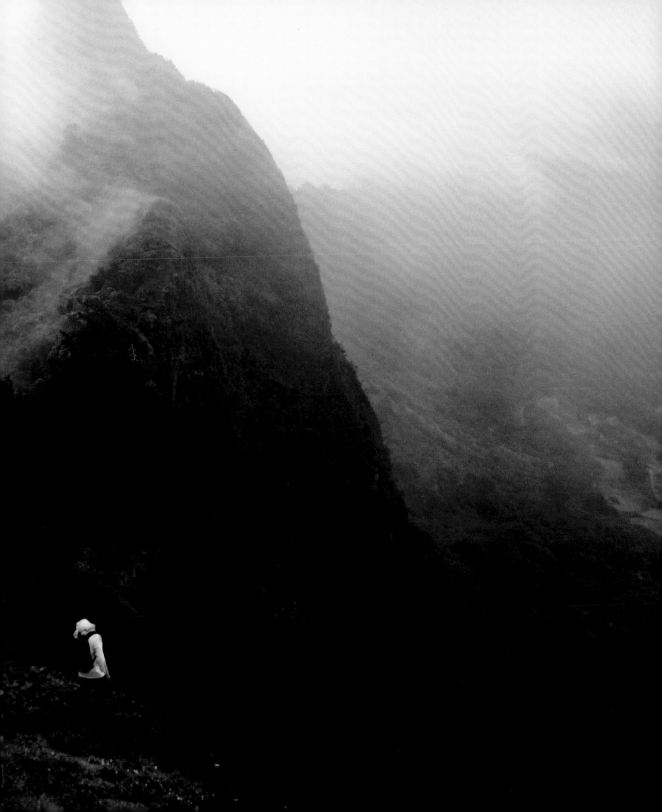

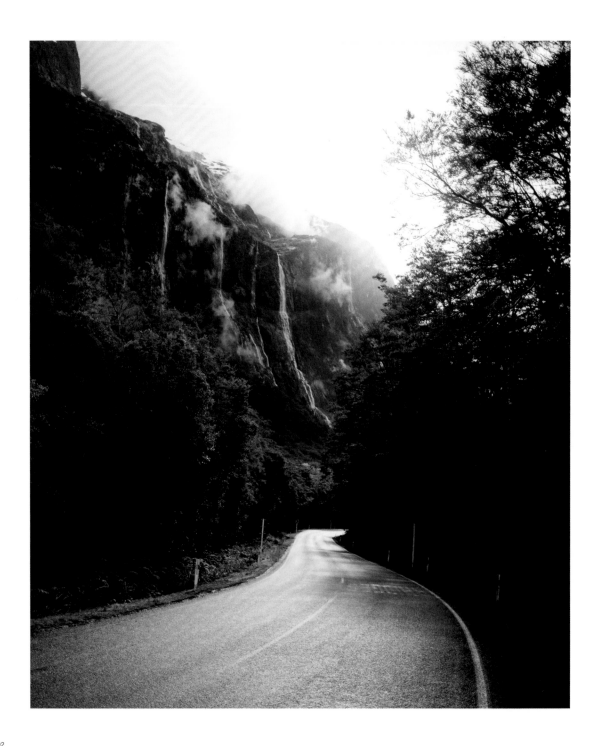

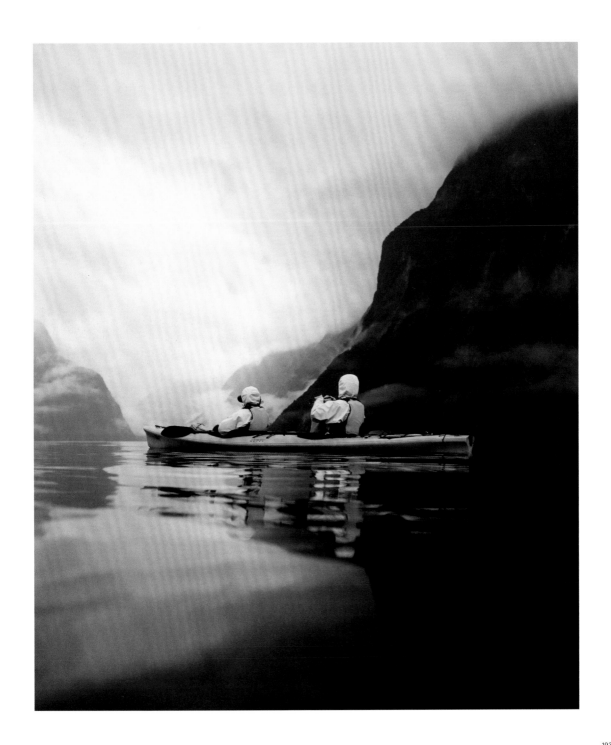

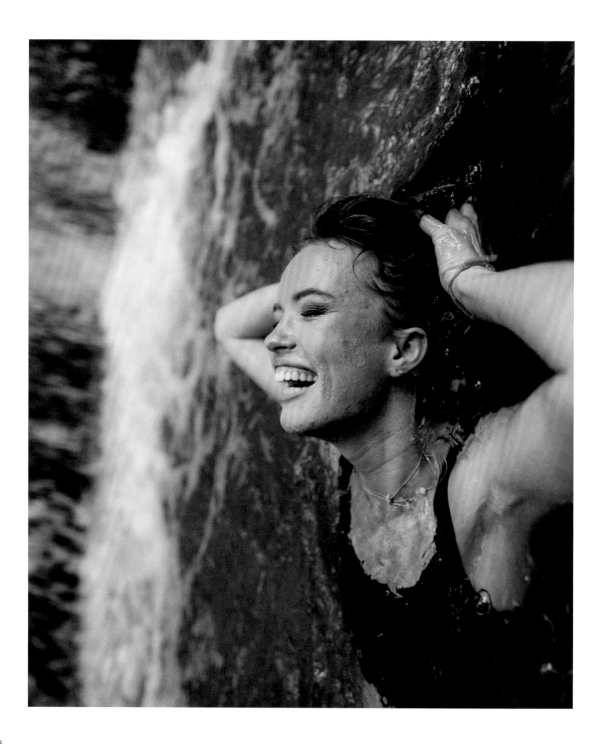

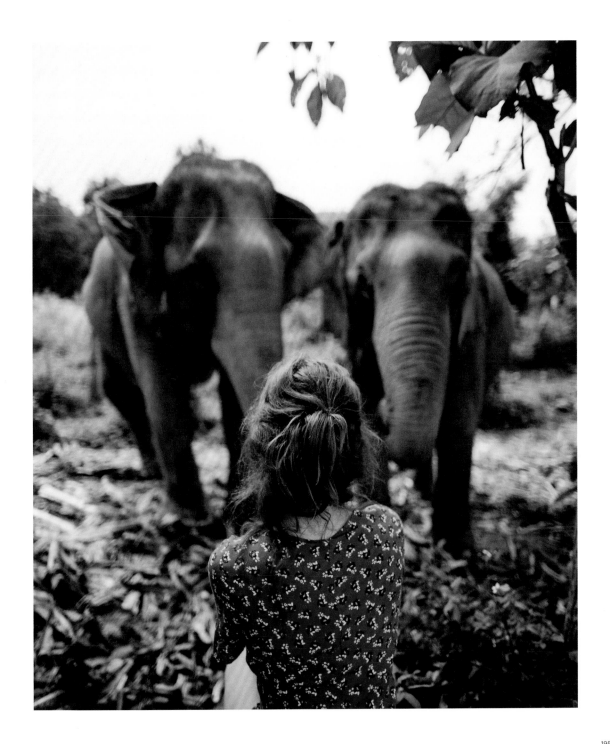

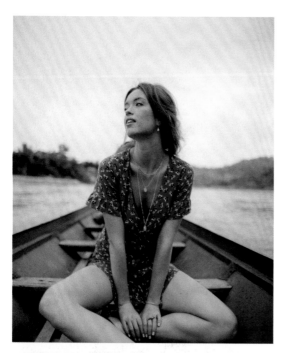

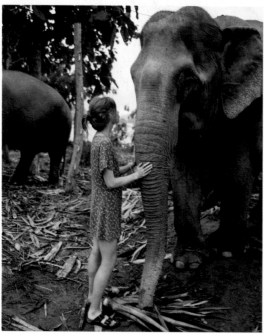

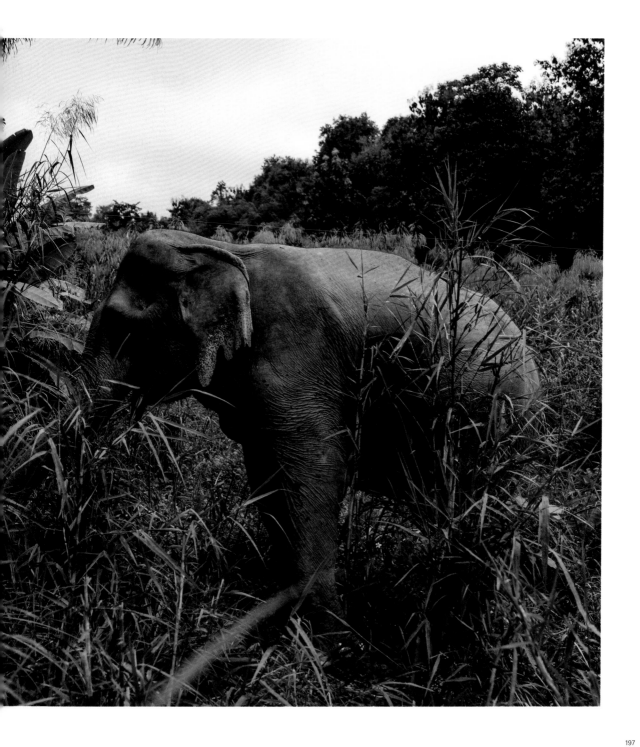

Dear future Forrest,

 Five years is a long time, especially long in Forrest years. It's impossible to even predict what will happen in the next five years when my present mind can't even make the simplest decisions. You will probably look upon me with some foreign expression while reading this, disregarding and trying to ignore memories of your younger, undeveloped self. Or maybe you will look upon me with some sense of nostalgia, wishing for these care free days to return. But more than likely, you will be reading this while thinking how fast the time has flown and what change it brought about. As I sit here now, I think about how long five years is, and what change I could wish for. It's a daunting task, deciding your future, but I know for sure one thing. In five years you will be. Through all of your accomplishments, failures, ups, downs and turns, you will simply be. You will be a changed man, a man of many things and influences, a man with an identity. As I sit here and write, I could wish for many things for you, but I hope you care not for these thing for you will be content with being. When happiness comes from within, that happiness becomes a part of you. All other goals and ambitions are erroneous without this happiness. Become the change you want to see and that change will become. I hope this is not too much to ask.

"A LETTER TO MYSELF IN FIVE YEARS"
17 YEARS OLD, COLORADO MAY—2014

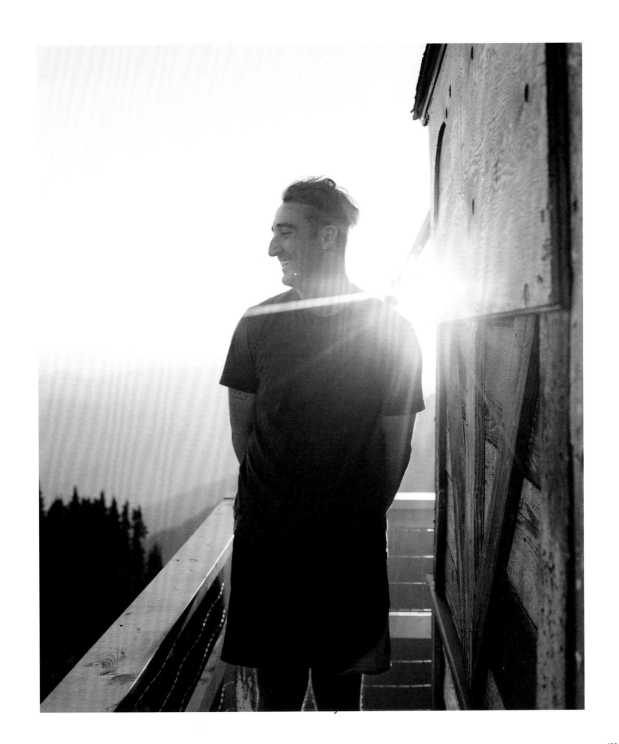

A special thanks to the inspiring souls featured in this collection:

Raimee Miller
Nick LaCava
Sarah Brush
Shannon Molvin
Elina Smith
Molly Molvin
Isabel Lucas
Joel Matuszczak
Michael Flugstad
Sarah Bethea
Mike Graef

Nata Sarafinchan
Bill Smith
Joshuah Melnick
Quin Schrock
Emily Evans
Caleb Wallace
Robin Farmer
Gabrielle Nelson
Baley Junes
Riley Rassmusen
Gordeon

THOUGHT CATALOG
CATALOG
Books

THOUGHT CATALOG BOOKS is a publishing imprint of Thought Catalog, a digital magazine for thoughtful storytelling. Thought Catalog is owned by The Thought & Expression Company, an independent media group based in Brooklyn, NY, which also owns and operates Shop Catalog, a curated shopping experience featuring our best-selling books and one-of-a-kind products, and Collective World, a global creative community network. Founded in 2010, we are committed to helping people become better communicators and listeners to engender a more exciting, attentive, and imaginative world. As a publisher and media platform, we help creatives all over the world realize their artistic vision and share it in print and digital form with audiences across the globe.

ThoughtCatalog.com
Thoughtful Storytelling

ShopCatalog.com
Boutique Books + Curated Products

Collective.world
Creative Community Network

Published by Thought Catalog Books, an imprint of the digital magazine Thought Catalog, which is owned and operated by The Thought & Expression Company LLC, an independent media organization based in Brooklyn, New York and Los Angeles, California.

Made in the United States, printed in Berlin, Germany.
ISBN 978-1-949759-20-4

This book was produced by Chris Lavergne and Noelle Beams. Art direction and design by KJ Parish. Special thanks to Bianca Sparacino for creative editorial direction and Isidoros Karamitopoulos for circulation management.

Visit us at thoughtcatalog.com and shopcatalog.com.